The Blackpool Sixth Form College

Title
Walker Art Gallery, The

Cla
Accn s12645

D0178693

The Walker Art Gallery

LIBRARY

CLASS No.
750

THE BLACKPOOL SIXTH FORM
COLLEGE LIBRARY

The Walker Art Gallery

Liverpool

LIBRARY	
ACCN. No.	CLASS No.
S12,645	

Scala Books

NATIONAL MUSEUMS & GALLERIES
· ON MERSEYSIDE ·

ALLIED LYONS

©1994 Scala Publications Ltd / Board of Trustees of the National Museums and Galleries on Merseyside

First Published in 1994
by Scala Publications Limited
26 Litchfield Street
London WC2H 9NJ

Distributed in the USA and Canada by
Rizzoli International Publications Inc.
300 Park Avenue South
New York
NY 10010
All rights reserved

ISBN 185759 036 8 (HARDBACK)
ISBN 185759 037 6 (PAPERBACK)

Designed and typeset by Robin Forster (Art to Go!)
Produced by Scala Publications Ltd.
Colour repro by Columbia Offset (UK) Ltd.
Printed and bound in Italy by Grafiche Milani, Milan

© Photography National Museums and Galleries on Merseyside

Cover: detail from *Echo and Narcissus* by **J.W. Waterhouse**

THE BLACKPOOL SIXTH FORM
COLLEGE LIBRARY

Contents

Sponsor's Preface

The Walker Art Gallery was founded in 1873 by a local brewer, Sir Andrew Barclay Walker, and we are proud that his company, Peter Walker Limited, still continues to flourish throughout Merseyside as part of our important international retailing business.

Allied-Lyons PLC have been keen supporters of the arts for many years so it is highly appropriate that we should carry on this tradition by giving our support to the Walker Art Gallery through the publication of this Guide.

Each year the Gallery plays host to art lovers from all over the world and the Guide will provide them with a memorable souvenir of their visit. It will also introduce the Gallery - and its splendid collections - to those who are unable to see them in person. I hope that it will give you lasting pleasure.

Michael Jackaman
Chairman
Allied-Lyons PLC

Foreword

The Walker Art Gallery is distinguished by the outstanding quality and variety of its collections. These range over many fields of painting, sculpture and decorative arts, but the Gallery is particularly strong in European Old Master painting, especially the early Italian and Netherlandish schools, British eighteenth century art, Victorian painting and sculpture, particularly the Pre-Raphaelites, and post-war British painting. This guidebook is intended to bring the collections to a wide audience and as a souvenir for the visitor. It presents a selection of 120 of the most beautiful and significant works of art. Each is illustrated in colour and accompanied by explanatory text. We hope that this publication will further one of the principal aims of the Trustees, to encourage the appreciation and enjoyment of art.

The collections of the Walker, and indeed the Gallery itself, are the result of a combination of private beneficence and public idealism. On the one hand, the Gallery was built at the expense of a private citizen, Sir Andrew Barclay Walker; and since his founding gift of 1873 many more of the great families of Liverpool have made important gifts and bequests both of funds and of works of art. On the other hand, the Walker throughout its history has been administered by public authority, first by the City of Liverpool, then, from 1974, by the Merseyside County Council, and more recently, since 1986, by the nation. The Walker now forms part of the National Museums and Galleries on Merseyside which is governed by a Board of Trustees and receives its funding directly from the Department of National Heritage. The award of national status was made in recognition of the high quality of the collections, which is evident even after a cursory glance at this guidebook.

National status has enabled the Trustees to initiate an ambitious programme of refurbishing its displays, so as to enhance the experience of a visit to the Gallery. There has also been a renewed effort to clean and conserve the collections, to extend the role of the education service and to continue the tradition of scholarship which has always been important at the Walker. We would like to thank the team of curators and educators who have written the texts: Edward Morris, Alex Kidson, Xanthe Brooke, Joseph Sharples, Robin Emmerson, Frank Milner, Sharon Trotter and Peter Betts. We are especially grateful to Edward Morris for co-ordinating the project and to Ron White and David Flower for most of the photography. Kevin Childs of Scala Publications has supervised the design and production with great care.

In today's difficult economic climate, when the public sector is placed under severe pressure, private generosity continues to play an essential part in all facets of the Walker's work, and it is with great pleasure that we acknowledge the assistance of Allied-Lyons plc and, through it, its local trading company Peter Walker Ltd., in sponsoring part of the publication costs. This continues the historic connection between the brewery and the Gallery, which dates back to the founding gift made in 1873 by Peter Walker's son, Sir Andrew Barclay Walker.

Many of the works of art featured in this guidebook were gifts, and of the purchases, most were made with the assistance of donations from individuals, companies or funding bodies. In particular we would like to acknowledge the help given consistently over the years by the National Art Collections Fund, now in its 90th year. We would like to dedicate this book to the memory of all our donors, in gratitude for their generosity and for the resultant pleasure given to the thousands of ordinary people who come to the Walker each year.

Richard Foster
Director, National Museums and Galleries on Merseyside

Julian Treuherz
Keeper of Art Galleries

The History of the Gallery & its Collections

The construction of the Walker Art Gallery was not begun until 1874, but some of its most important paintings had been on public display in Liverpool since 1819. In that year thirty-seven small paintings were hung in the Liverpool Royal Institution. The catalogue published to record them contained this explanation of the motives behind the collection:

> A few individuals, conceiving that, as the following PICTURES form a series from the commencement of the Art to the close of the fifteenth century, their value would be enhanced by their being preserved together, have united in purchasing and presenting them to the LIVERPOOL ROYAL INSTITUTION; in the hope that, by preventing the dispersion of a collection interesting to the history, and exemplifying the progress of Design, they may contribute to the advancement of the FINE ARTS in the Town of Liverpool.

The collection thus partially saved from dispersal was that of Liverpool's most eminent citizen, William Roscoe, notable as historian, collector, botanist, poet, philanthropist, Radical politician, banker and lawyer. He had himself always wanted his collection to be of public benefit, although the failure of his bank compelled him to sell it in 1816. The 'few individuals' who saved this part of his collections were mainly his friends and associates among the Nonconformist Radical merchants of Liverpool. Their belief that public collections would improve and refine taste and quality among collectors, manufacturers and artists lay behind the creation of most museums and art galleries in nineteenth-century Britain and this is probably the first practical, public and explicit expression of the idea.

The Liverpool Royal Institution was partly just a cultural club for Liverpool's wealthy merchants but in addition it organized an ambitious programme of adult education, sponsored a grammar school and provided meeting rooms for serious local societies. Also among its aims, defined in 1814, were 'collections of books, specimens of art, natural history etc', and thus the gift of Roscoe's pictures enabled it to fulfil one of its objectives. The display of these paintings was improved by the construction in 1840-43 of a new purpose built art gallery adjacent to the Royal Institution's main premises in Colquitt Street; it had an upper floor with sophisticated lighting for pictures and a lower floor for casts and sculpture; soon more works of art were acquired - mainly old master paintings - by purchase and gift on a modest scale.

The Royal Institution was run by its proprietors. Those individuals who had contributed to its formation received in exchange shares which they could sell or bequeath to their heirs; the owners of these shares and their families alone had the right to enjoy the Royal Institution's facilities, but the general public were admitted in return for a fee or, occasionally, as at the art gallery on some Mondays, free of charge. This system of

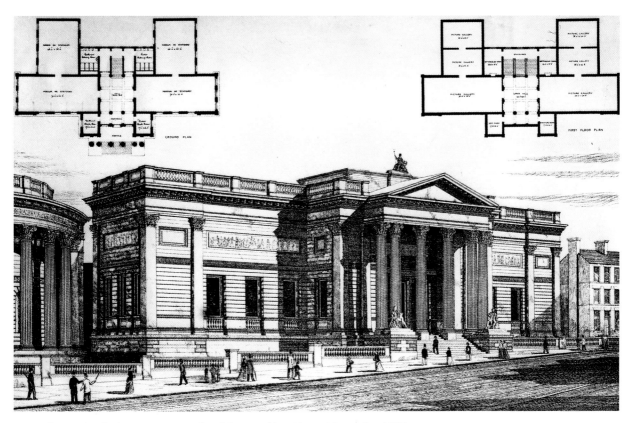

The Gallery as first built 1874-77 (reproduced from *Building News*, 7 September 1877)

financing meant that the Royal Institution had, despite small grants from the Town Council, only a very modest regular income and even with art classes (incorporating a nude female model), lectures on art history and the publication of a whole series of scholarly catalogues of the collection, the new art gallery did not prove very popular. In 1850-51 negotiations began between the Royal Institution and the Liverpool Town Council involving the transfer of the Institution and its art collections to the Town Council, which had by that time been authorized by Parliament to provide museums and art galleries at the expense of its ratepayers. The Institution's proprietors, however, wanted to retain some control over its collections and educational programme, even after the takeover by the Council, and to this the Council would not agree.

After the failure of these negotiations the Liverpool Town Council did build the William Brown Library and Museum between 1857 and 1860 but took little more direct interest in art galleries until 1860 when its Committee of the Free Public Library, Museum and Gallery of Arts reported that 'up to the present time little or no opportunity has been afforded for the development of the latter department, but it has by no means been lost sight of by the Committee'. The Committee then went on to list some portraits, casts and subject pictures which had been presented to the Council or commissioned by it and of which most had been placed temporarily in its new museum and library buildings; they were to be the nucleus of the future 'Gallery of Arts'. During the 1860s, plans for the new public art gallery were drawn up, but building was delayed by financial considerations. In 1871 the first Liverpool Autumn Exhibition was arranged by the Council in the Museum; this was an exhibition of paintings by living artists for sale - a provincial version of the Royal Academy Summer Exhibitions. The Liverpool Academy had organized similar 9

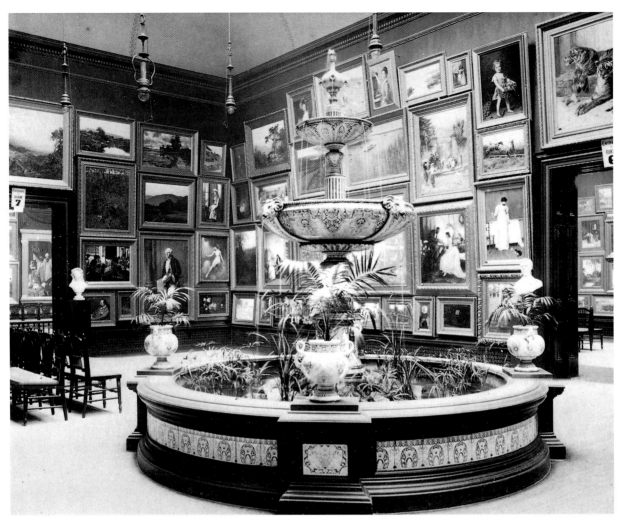

The Liverpool Autumn Exhibition of 1882 held in the Gallery

exhibitions earlier in the century but these had collapsed due to feuding between artists and to competition from other exhibiting societies. The Autumn Exhibitions were, however, very successful, yielding in particular, a substantial profit. This encouraged the Council to spend £500 on buying pictures mainly from the exhibition for the still unbuilt art gallery. Similar exhibitions were held in the following years and more paintings purchased until in 1873 Andrew Barclay Walker, having been elected Mayor of Liverpool, gave £20,000 towards the erection of a public art gallery which was to bear his name. The architects were local men, H.H. Vale and Cornelius Sherlock who was also responsible for the adjacent Picton Reading Room of 1875-79.

Walker was a brewer and although not notable as a collector or patron of art, he erected public houses in Liverpool of considerable architectural quality and gave generously to many local good causes - no doubt partly to improve the public image of brewing and of alcohol in general at a time when the temperance movement, largely sponsored by his political adversaries, the Liberals, was growing in strength. The Walker Art Gallery opened to the public in 1877 primarily to house the annual temporary Liverpool Autumn

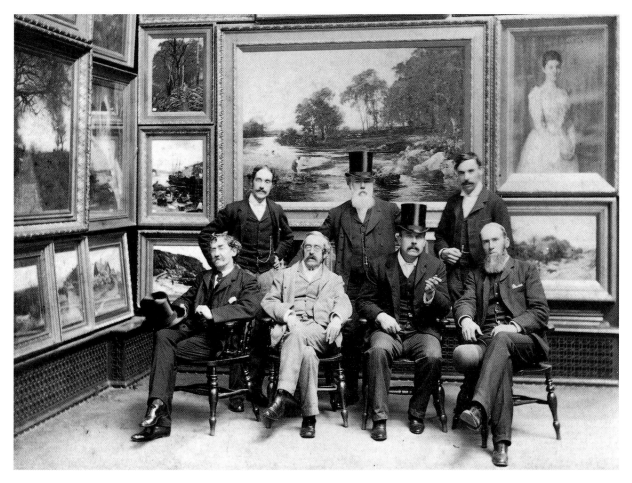

The Hanging Committee at the 1891 Liverpool Autumn Exhibition held in the Gallery; in the front row left to right are J.M. Whistler (artist), P.H. Rathbone (Gallery Chairman and Chairman of the Committee), Arthur Melville (artist) and W.B. Boadle (artist); in the back row are H. Frazer (Gallery assistant), Charles Dyall (Gallery Curator) and J.H. Ward (Gallery assistant)

Exhibitions which had been dislocating the Museum's displays each year since 1871. The profits from these exhibitions, however, continued to be spent on increasing the size of the permanent collection, which by 1885 included some 360 works of art. The source of this funding encouraged the Council to buy almost exclusively contemporary British paintings and sculpture mostly from the Autumn Exhibitions, although within these limits the selection was often far-sighted and adventurous.

It was the growth of the permanent collection which encouraged the Council to enlarge the Gallery in 1882 and again Walker paid the entire cost (£11,500). Liverpool could now claim to have the finest art gallery outside London and attendance figures peaked at 610,779 in 1880 (2,349 each day) - a figure never subsequently exceeded. In 1893 most of the paintings owned by the Liverpool Royal Institution were placed on long term loan for display at the Walker Art Gallery and, with the decline in vitality of the Autumn Exhibitions following the death of their principal organizer, P.H. Rathbone, in 1895, the permanent collection rather than loan exhibitions became the principal feature of the Gallery.

A number of important gifts, mainly of nineteenth-century art, were received from James Smith and from George Audley in the 1920s and 1930s, and in 1929 for the first time a contribution from the rates (£750) was made to the picture purchase fund which

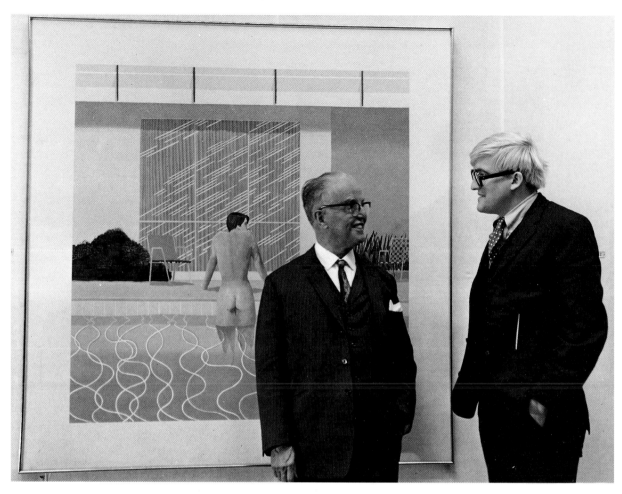

Sir John Moores and David Hockney at the 1967-68 John Moores Liverpool Exhibition with Hockney's painting *Peter getting out of Nick's pool.*

before then had been dependent on gifts and on the diminishing profits from the Autumn Exhibitions. Purchasing became less restrained in scope and in the 1930s and 1940s, with Vere Cotton as Chairman of the Libraries, Museums and Arts Committee of the Liverpool City Council and with Frank Lambert as Director of the Gallery, notable eighteenth century British works and important Camden Town paintings from the early twentieth century were acquired. This bolder policy was also assisted by a bequest in 1933 of £20,000 from Lord Wavertree, son of Andrew Barclay Walker.

Meanwhile the Gallery was again extended and the entrance hall re-modelled in 1931-33, thanks to gifts from George Audley, Sir Frederick Bowring, Thomas Bartlett and others; the architect was Arnold Thorneley of Briggs and Thorneley, who had designed the Mersey Docks and Harbour Board Offices in 1907. It is noteworthy that the Walker Art Gallery has depended on private generosity both for its buildings and for its collections to a much larger extent than most other British art galleries - although it is also true that, of the vast and important collections of nineteenth-century British art formed by Liverpool merchants, relatively little now survives in the Walker Art Gallery.

The Gallery closed during the Second World War and only re-opened in 1951, but in 1948 the Liverpool Royal Institution paintings already on loan to the Gallery were presented to it. Under Hugh Scrutton as Director, purchasing policy again widened to

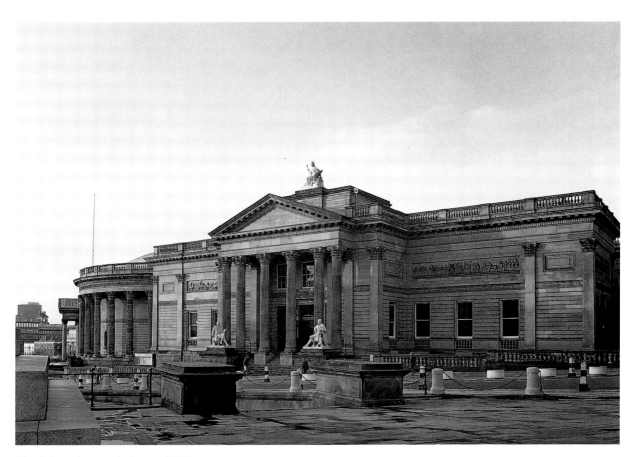

The Gallery photographed around 1980

include old master paintings and, from 1961 onwards, French impressionist and post-impressionist paintings, many of which were bought through a special appeal for funds directed to Merseyside industry and commerce. The biennial John Moores Liverpool Exhibitions began in 1957 under the joint sponsorship of Sir John Moores and of the Gallery and thanks to them the Gallery was able to re-establish its original role of acquiring on a regular basis major examples of British contemporary art. There was a new emphasis on conservation, and after the war J. Coburn Witherop set up a studio for the conservation of paintings in the Gallery, while between 1963 and 1988 seven rooms were fully air-conditioned in order to protect the fragile early paintings on panel. Education was not neglected with the appointment of the Gallery's first full-time Schools Officer in 1957, and, following in the tradition of the Liverpool Royal Institution, detailed scholarly catalogues of the collections began to be written and published.

With the reform of local government in 1973 the Merseyside County Council assumed responsibility for the Gallery; following the abolition of the Council in 1986 the Gallery received national status as part of the newly formed National Museums and Galleries on Merseyside. The Gallery had assumed responsibility for the Emma Holt Bequest of eighteenth and nineteenth-century British paintings and for Sudley, where they were - and still are - displayed, in 1945, but in 1978 it acquired a yet more important function when the Lady Lever Art Gallery in Port Sunlight also came into its care. Cumulatively these three expressions of confidence in the Walker Art Gallery confirmed its role as the leading English provincial art gallery.

13

chapter 1

The Middle Ages
& early Renaissance

The Walker Art Gallery was not founded with a conscious policy to collect either medieval or early Renaissance art and therefore the outstanding quality of this part of the collection is, in some ways, surprising. The majority of the works come from two private collections amassed by the nineteenth-century Liverpool collectors William Roscoe and Joseph Mayer. The two men were keen antiquarians: Mayer collected and studied examples of Roman, Egyptian and medieval artifacts, Roscoe was interested in the history and development of Renaissance art. Both men perceived their collections as having an educational role and hoped that the city as a whole would benefit from them.

William Roscoe (1753-1831) acquired a large number of the paintings in this part of the collection between 1804 and 1816. He was a successful Liverpool lawyer and Radical politician whose interests included history, poetry, botany, languages and art. Remarkably, he was, on the whole, a self-educated man. Much influenced by the example of the Renaissance patrons - he wrote a notable history of Lorenzo de Medici in 1796 - Roscoe was eager to promote cultural development in the expanding commercial centre of Liverpool. He was active in the formation of both the Liverpool Royal Institution and the Athenaeum Library, and became himself a significant collector, starting first with books and then extending his interest to prints and finally 'primitive' - that is fourteenth and fifteenth-century - paintings and drawings.

Unfortunately, the threat of bankruptcy in 1816 forced Roscoe to sell off his collection. Writing about these works in the sale catalogue obviously intended as a memorial to the collection, Roscoe stated that they had been acquired 'chiefly for the purpose of illustrating by reference to original and authentic sources the rise and progress of the arts in modern times as well as in Germany and Flanders as in Italy. They are therefore not wholly to be judged of by their positive merits but by reference to the age in which they were produced. Their value depends on their authenticity and the light they throw on the history of the arts. . .' A substantial number of Roscoe's works have been reattributed since he published this catalogue so that in one sense his faith in their 'authenticity' was misplaced. However, the pictures are authentic in the sense that Roscoe did acquire genuine medieval paintings and that they do provide a comprehensive overview of the development of art at that time.

After the sale a large group of Roscoe's works found their way into the collection of the Liverpool Royal Institution, mainly due to the determined spirit of William Rathbone, Radical merchant and close friend of Roscoe. Here the collection was extended and finally given to the Walker Art Gallery by the Institution in 1948.

Joseph Mayer (1803-86) was born in Newcastle-under-Lyme, Staffordshire. He moved to Liverpool when he was twenty. At first he was apprenticed to his brother-in-law,

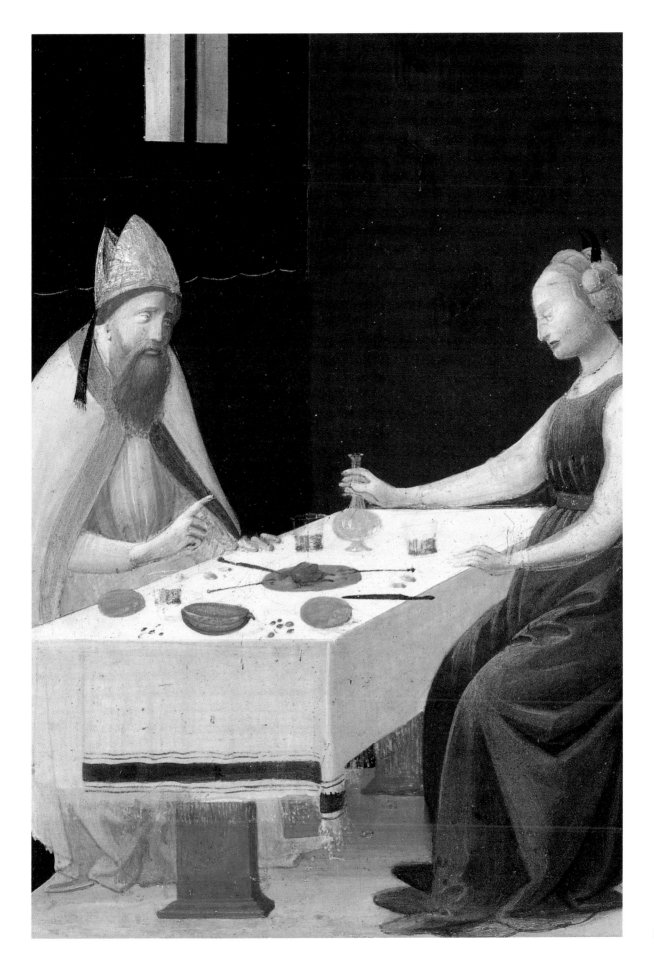

15

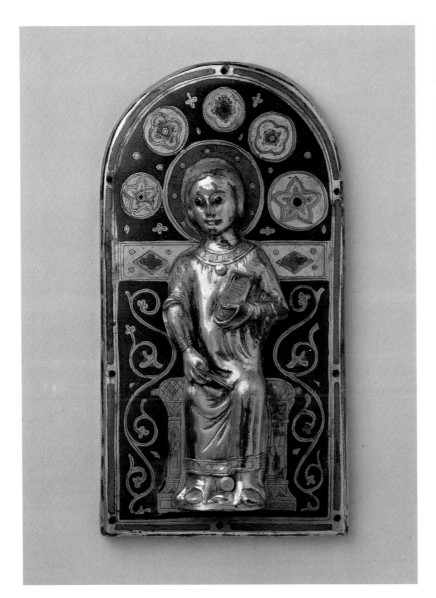

French (Limoges)
Plaque from a book-cover, 1200-25
Enamel on copper, 11.3 x 20.5 cm
Presented by Joseph Mayer, 1867;
inv. no. M9

Limoges was the principal centre for the production of enamelled metalwork in Europe in the 13th century. The figure of St John the Evangelist suggests that this was intended as the cover for a gospel book.

Joseph Wordley, a jeweller but in 1844-45 Mayer set up his own jewellery and silversmith business. It was probably this enterprise which provided him with sufficient funds to finance his passion for collecting. Mayer's interest in antiquities began at an early age and his collection covered a wide range of subjects including Wedgwood pottery, Egyptian and Roman artifacts, English paintings and medieval art. Unlike Roscoe who never left England, Mayer travelled abroad regularly. Primarily he travelled on business to observe trends but each of his trips provided the opportunity for him to study and purchase ancient and medieval art. In 1852 Mayer opened a museum in Colquitt Street, using works he himself had collected as the exhibits. He had become captivated by the displays at the British Museum and wished his fellow-citizens of Liverpool to have the same opportunity to view the wonders of the past. As well as setting up the museum Mayer was a founder member of the Historic Society of Lancashire and Cheshire, established in 1848, and a fellow of the Society of Antiquaries. In 1867 Mayer gave his collection to the Liverpool Museum. The medieval manuscripts, ivories and enamels which made up part of this gift are now in the care of the Walker Art Gallery.

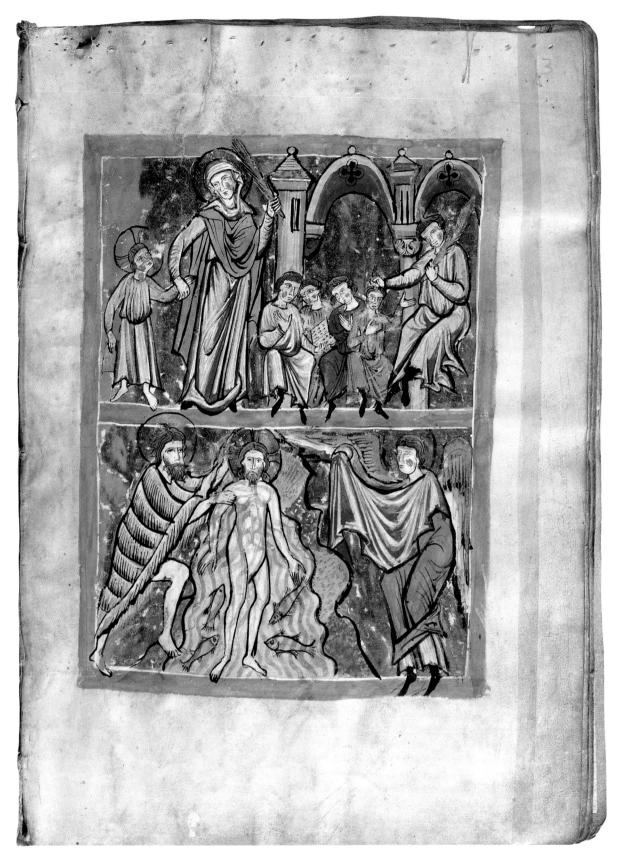

South German
Psalter, 1225-50
Vellum, 25.7 x 18.5 cm
Presented by Joseph Mayer 1867;
inv. no. M12004

Psalters are service books containing all the Psalms and prayers. They were used by the clergy from the 9th century but became increasingly popular with lay readers from the 12th. This manuscript was probably produced in a monastic house but for a lay reader. In style it is close to the Ochsenhausen Psalter (Paris, Bibliothèque Nationale). The illumination on page 13 depicts two scenes from the Life of Christ: at the top Mary leads Christ to school - an unusual subject - and below Christ is baptised by St John the Baptist.

Spinello Aretino (active 1373-1410 or 1411)
Italian (Arezzo and Florence)
Salome, c. 1390
Fresco, 39.5 x 31 cm
Formerly in the collection of William Roscoe.
Presented by the Liverpool Royal Institution,
1948; inv. no. 2752

The fresco technique, in which paint is
applied directly to wet plaster, was used for
mural decorations throughout Italy from the
13th century onwards. This fragment comes
from a destroyed chapel in the Florentine
church of Santa Maria del Carmine, where it
formed part of a scene showing the Feast of
Herod in a cycle illustrating the life of St John
the Baptist. The Gospel of St. Matthew tells
how Salome, the daughter of Herodias,
danced seductively before the Jewish king
Herod, who in return ordered the execution
of the Baptist which Herodias had demanded.

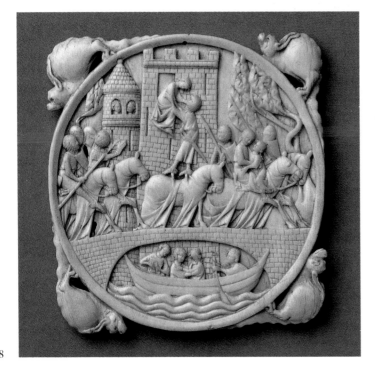

French
Mirror case, c. 1320
Ivory, diameter 13.3 cm
Presented by Joseph Mayer, 1867;
inv. no. M8010

An elopement from a castle is shown in four
scenes. The lady appears three times: being lifted
down from the tower, being carried away on
horseback, and (below) with her lover in a boat.

Simone Martini (c. 1284-1344)
Italian (Siena)
Christ discovered in the Temple, 1342
Panel, 49.6 x 35.1 cm
Formerly in the collection of William Roscoe.
Presented by Liverpool Royal Institution, 1948; inv. no. 2787

When still a young child, Christ abandoned his parents during a visit to the Temple in Jerusalem and stayed behind to teach among the scholars there. His mother's words on finding him again are written in Latin on the book she holds: 'Son, why have you dealt with us like this?'

The picture is signed and dated in Latin along the bottom edge of the frame: 'Simone of Siena painted me in the year of Our Lord 1342'. Simone was among the greatest artists of 14th-century Italy, but at this date he was working at Avignon in France, where the papal court was in exile from Rome. This sumptuous picture was presumably commissioned for private devotion by a high ranking patron, possibly the pope himself. The jewel-like colours, the use of richly patterned gold, and the linear gracefulness of the figures are characteristic of the Gothic art of France as well as Italy. It is typical of Simone that these decorative qualities do not detract from the solemn emotional drama of the scene which is conveyed through gesture, pose and facial expression.

Maso Finiguerra (1426-64)
Italian (Florence)
Pax, c. 1450
Silver, niello, 5 x 8 cm
Presented by Joseph Mayer, 1867;
inv. no. M61

Decorated with the Ascension of Christ.
A pax was made for worshippers to kiss at
Mass. It replaced the Kiss of Peace which
they had given each other, but which was
thought unseemly by about 1300. This pax
is now set in a 19th-century silver frame
(not shown).

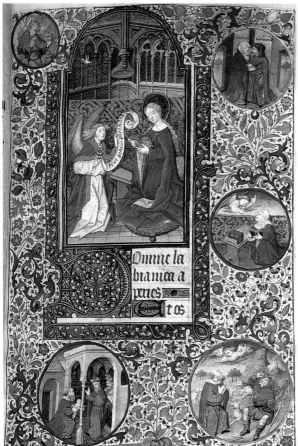

French (Paris)
Book of Hours, 1440-50
Vellum, 21.8 x 15.8 cm
Presented by Joseph Mayer 1867;
inv. no. M12001

Books of Hours are prayer books which were
produced in the late Middle Ages, primarily for
a lay readership. This Book of Hours is close in
style and composition to later manuscript illu-
minations from the workshop of the Bedford
Master which flourished in Paris in the first half
of the 15th century. The Annunciation scene on
the page illustrated (folio 37) introduces the
Hours of the Blessed Virgin Mary, which begins
with the standard words 'Domine labia mea
aperies', ('O Lord open thou my lips'). In the
border, roundels contain subsidiary scenes from
the Christmas story.

Bartolomeo Montagna
(c. 1440-1523)
Italian
The Virgin and Child with a
saint, c. 1483-99
Panel, 37.8 x 36.5 cm
Purchased in 1978 with the
help of the National Art
Collections Fund;
inv. no. 9375

Montagna was greatly
influenced by Venetian
artists such as Giovanni
Bellini and did much of his
work in Vicenza and
Verona. The saint has been
tentatively identified as St
John the Baptist although it
is unusual to depict an adult
St. John paying homage in
this way to a Christ Child.
In the past it has been sug-
gested that the bearded fig-
ure was Francesco
Gonzaga, husband of
Isabella d'Este, but the halo
above the figure is original
to the painting.

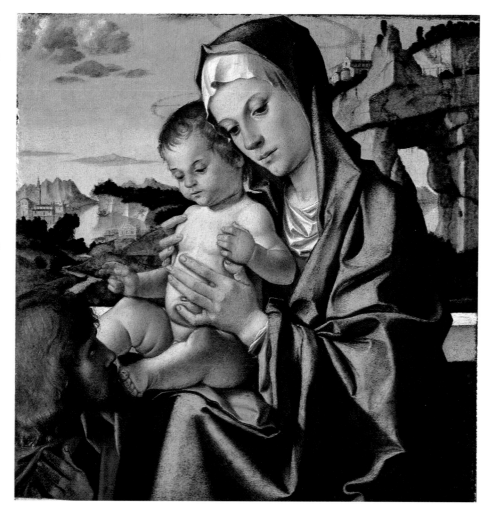

Master of the Virgo inter Virgines
(active c. 1474-95)
Dutch (Delft)
The Lamentation over the Dead Christ,
c. 1486-87
Panel, 55.2 x 56.3 cm
Formerly in the collection of Willam Roscoe.
Presented by the Liverpool Royal Institution
1948; inv. no. 1014

The anonymous Master of the Virgo inter
Virgines was a leading artistic figure in the
Northern Netherlands during the late 15th
century. His name derives from one of his
works which represents the Virgin and Child
among four holy virgins (Rijksmuseum,
Amsterdam). His works are distinguished by
their austere colouring, emotional piety and
ability to express overwhelming grief. The
scene's poignant and horrific drama is
emphasised by the desolate landscape and
skull-like heads of the richly-dressed figures.

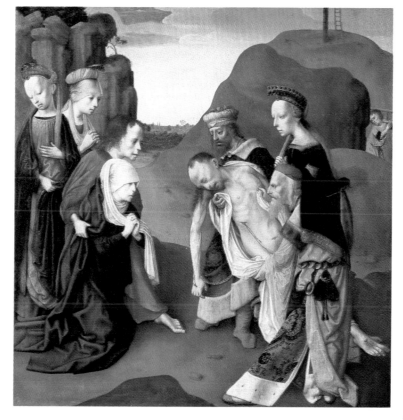

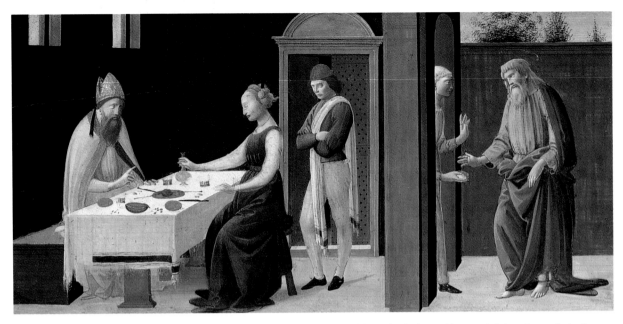

Bartolommeo di Giovanni (active 1485-1510)
Italian (Florence)
A Legend of St Andrew, c. 1490
Panel, 25 x 52 cm
Formerly in the collection of William Roscoe.
Presented by the Liverpool Royal Institution, 1948;
inv. no. 2756

According to medieval legend, a bishop with a special devotion to St Andrew was visited by the devil in the form of a young woman, but was saved from temptation by the miraculous appearance of St Andrew himself, who revealed the true identity of his guest. The saint is on the right of the picture, seeking admission to the bishop's house. The seated woman has a pair of tell-tale horns. The table setting is a rare illustration of 15th-century cutlery, including early two-pronged forks.

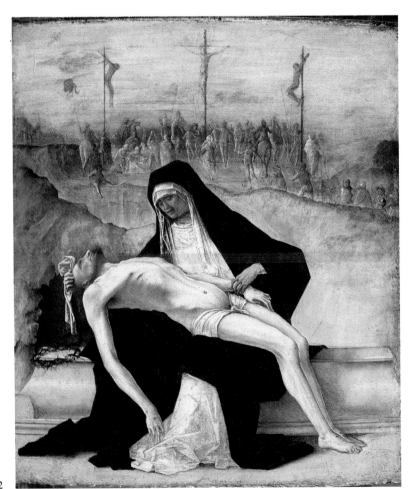

Ercole de' Roberti (active 1479-96)
Italian (Ferrara)
Pietà, c. 1495
Panel, 34.4 x 31.3 cm
Formerly in the collection of William Roscoe.
Presented by the Liverpool Royal Institution 1948; inv. no. 2773

This centre predella panel is part of a large altarpiece that is still in the church of San Giovanni in Monte, Bologna. Originally the panel was positioned above the altar directly in front of the priest's face as he celebrated Mass. Pietà (Italian for 'pity') was a type of Northern European devotional subject that is without scriptural basis. Pietàs were imported into Italy from about 1450. Christ's unidealised blood-drained body, Mary's angular black cloak, her anguished face, and tender clasping of her dead son all combine to create an intense emotional effect. This is usually considered Ercole's masterpiece and is one of the finest of William Roscoe's pictures.

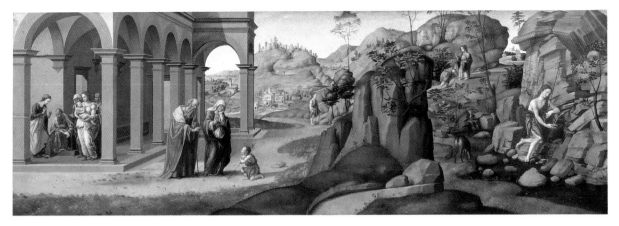

Circle of Francesco Granacci (1477-1543)
Italian (Florence)
Scenes from the life of St John the Baptist,
c. 1505-10
Panel, 77.4 x 228.6 cm
Bequeathed by P.H. Rathbone, 1895;
inv. no. 2783

Several incidents from the saint's childhood are combined here in chronological order from left to right. The panel comes from a series illustrating the life of the Baptist - the patron saint of Florence - which may have decorated a private chapel in the city. Other panels from the same group are now in the Metropolitan Museum in New York. The loggia on the left is an elegant example of Florentine Renaissance architecture, and like the beautiful landscape background it gives the New Testament figures a 16th-century Italian setting.

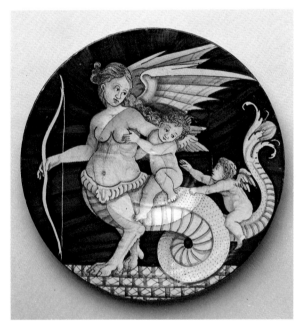

Italian (Deruta)
Dish, 1500-20
Tin-glazed earthenware (maiolica), diameter 22.5 cm
Purchased with the help of the Friends of the National
Museums and Galleries on Merseyside, 1988; inv. no. 1988.361

Renaissance designers were fascinated by the monsters of Greek mythology and added their own improvements. It is often uncertain, as with this piece, whether an allegorical meaning was intended.

Luca Signorelli (c. 1441-1523)
Italian
Study of a youth, c. 1500
Black chalk with white gouache on paper, 41 x 21.5 cm
Presented by H.M. Government 1981; inv. no. 9833

A magnificent study of a young apprentice: it is pricked along the figure edge and also 'squared up' to aid transfer on to a large scale. Drawings like this were kept on file in artists' studios and used as required to help compose both altarpieces and large wall frescos.

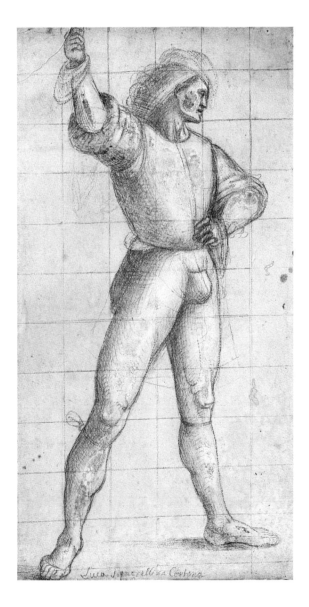

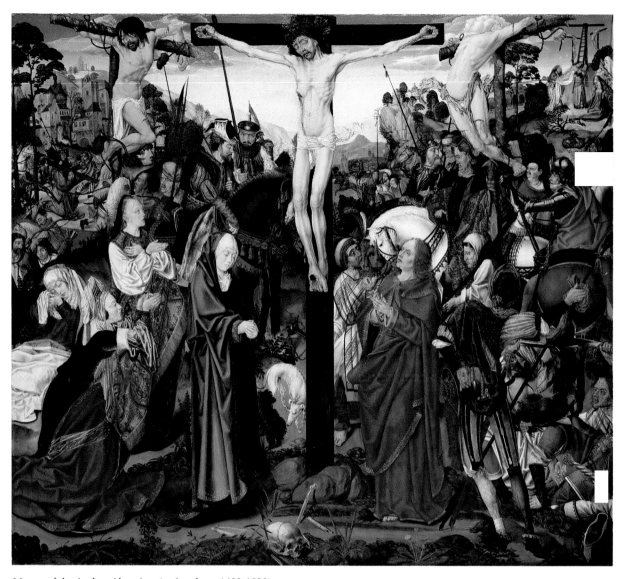

Master of the Aachen Altarpiece (active about 1480-1520)
German (Cologne)
Altarpiece with scenes from the Passion and Crucifixion, c. 1500
Panel, 109.1 x 54.2 cm, 106.8 x54 cm (the two wings)
The wings opposite were presented by the Liverpool Royal Institution in 1948; the central panel above is on loan from the National Gallery, London (No 1049);
inv. nos 1225, 1226

The left-hand panel showing Pilate washing his hands may include in the man looking over Pilate's shoulder a self-portrait of the artist, named after an altarpiece now in Aachen Cathedral. The backs of the wings show the Cologne mayor, Hermann Rinck, and his family at prayer in their private chapel in front of a vision of Christ appearing at Mass and showing his wounds to the 6th-century saint, Pope Gregory the Great. The triptych was originally in the parish church of St Columba in Cologne.

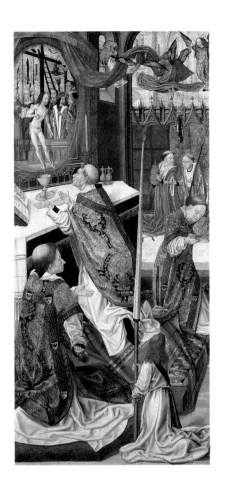

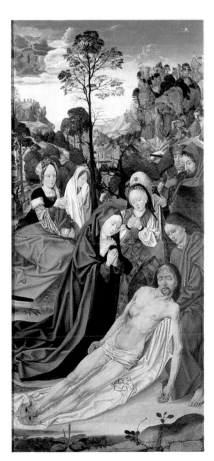

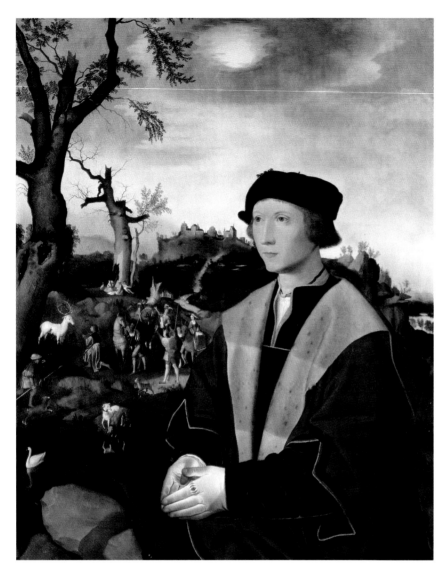

Jan Mostaert (c. 1473-1555/6)
Dutch (Haarlem, Malines)
Portrait of a young man, c. 1520
Panel, 96.6 x 73.7 cm
Formerly in the collection of William
Roscoe. Presented by the Liverpool
Royal Institution 1948; inv. no. 1018

In 1519 Mostaert was appointed
court painter at Malines to Margaret
of Austria, Governess of the
Netherlands. He produced for her
mainly portraits of the royal family,
although most of his known pictures
are of lesser members of the Dutch
nobility, as is probably this portrait.
He favoured a reserved dignified por-
trait style. He was also a good land-
scape painter rendering his back-
grounds in minute detail. In the
background appears the conversion
of St Hubert, who, while hunting on
a holy day, saw a stag with a crucifix
between its horns. The young man
portrayed may have been called
Hubert.

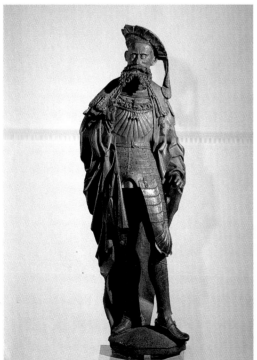

Master of Elsloo (active 1500-c1550)
Dutch (Roermond)
Bearded man in armour, c. 1515-20
Oak, height 165 cm
Purchased 1963; inv. no. 6215

The sculptor is named after a major
piece of his in the Dutch town of
Elsloo. The figure wears a scallop
shell breast-plate and the
Burgundian Order of the Golden
Fleece and could represent a military
saint. In the 19th century the figure
adorned the Great Hall at
Scarisbrick Hall, Lancashire.

Joos van Cleve (c. 1480-1540)
Flemish (Antwerp)
Virgin and Child with Angels,
c. 1520-25
Panel, 85.5 x 65.5 cm
Purchased 1981 with the help of the
National Art Collections Fund and the
National Heritage Memorial Fund;
inv. no. 9864

Joos van der Beke (called Cleve after
his native town) can be documented in
Antwerp from 1511. Joos and his
workshop produced a large number of
devotional panels devoted to the
Virgin and the Holy Family. He
worked in a style typical of the
Antwerp Mannerists using colourful
and elaborate costumes, fluttering
drapery and showy detail of plants,
architecture and landscape. He was
also one of the artists who introduced
the Italianate style to the Netherlands.
This painting reveals the influence of
Leonardo, especially in the forms of
the angels.

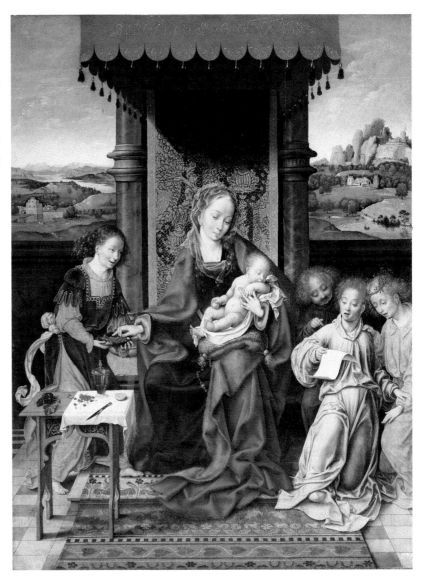

Flemish (Brussels)
Triumph of Fortitude, c. 1525
Wool and silk, 411 x 533 cm
Presented by Martins Bank Ltd 1953;
inv. no. 4115

The tapestry represents various male
and female figures from mythology,
classical and biblical history who
showed fortitude. The design was one
of a series of 'Triumphs' of the seven
virtues. The tapestry may originally
have been in a Spanish collection. The
Latin inscription in the upper border
may be translated as: 'Virtue (enables)
fearless hearts to oppose threatening
dangers. In the same way salvation
accepted from death pleases'.

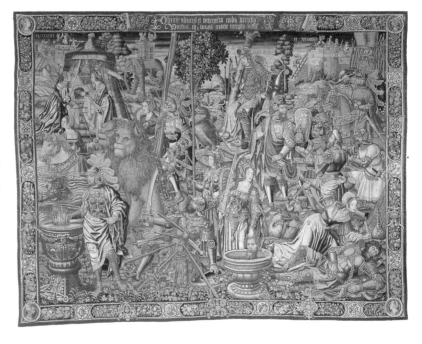

chapter 2

High Renaissance, Mannerism & Baroque

The Walker's collection of sixteenth- and seventeenth-century Italian, Spanish and Netherlandish art is unusual among British public collections in its bias towards Mannerism. Like the medieval and early Renaissance holdings the core of the collection of paintings and drawings of this period was formed by William Roscoe at the beginning of the nineteenth century. The Walker owes to him the *Portrait of a young man* by Rosso Fiorentino and the drawing by Rosso's Italian compatriot and rival at Fontainebleau Palace, Francesco Primaticcio's *Ulysses shooting through the rings*. Roscoe's failure to acquire major works of the Florentine and Venetian High Renaissance was due primarily to lack of finance, but his attraction to Mannerist art was probably related to his friendship with and support of the British based Swiss artist Fuseli, who greatly admired the work of Michelangelo and his Mannerist followers. Like Roscoe's early Italian and Netherlandish paintings his collection of Mannerist art would have been viewed with disfavour. Such emotionally charged art was not greatly admired as it did not fit the traditional canons of classically derived art. At the beginning of the nineteenth century, when Roscoe was collecting, the Napoleonic Wars on the continent released on to the British market many works of art. *The Nymph of the fountain* by Cranach, the most important German artist of the early sixteenth century, was in the hands of a Liverpool dealer by 1815, having 'been lately brought from the continent'.

The Primaticcio was once in Roscoe's substantial collection of drawings, which unlike his picture collection was dispersed after his bankruptcy. Other recent additions to the Walker's drawings collection include a Guercino and a Ribera both from the outstanding collection put together in the eighteenth century at Holkham Hall, which Roscoe knew well as he helped to catalogue the library for his friend Thomas Coke, later the Earl of Leicester. Examples of British Renaissance portraiture by Holbein and Hilliard came from equally eminent collections. The *Portrait of Henry VIII* by Holbein and his workshop had traditionally belonged to the family of Jane Seymour and was perhaps acquired by her brother Edward Seymour, 1st Duke of Somerset, leading courtier at the court of Henry VIII and Lord Protector of England during the early years of the reign of Edward VI.

The Walker's collection of seventeenth-century art is characteristic of the many British eighteenth- and nineteenth-century aristocratic collections from which the Gallery derives several of its more important paintings, especially in its concentration of Dutch paintings, its focus on landscape art and in its holdings of a quartet of prestigious Old Masters - paintings by Rembrandt, Rubens, Poussin and Murillo. All four of the Walker's paintings by these artists came from aristocratic collections as diverse as those of Charles I, the Duke of Devonshire, the Earl of Derby and Lord Overstone.

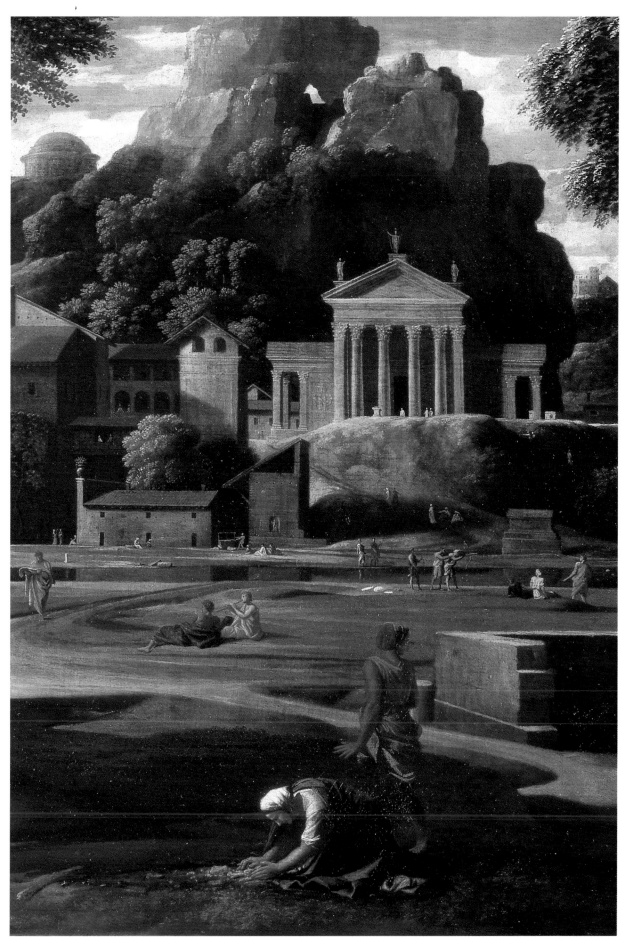

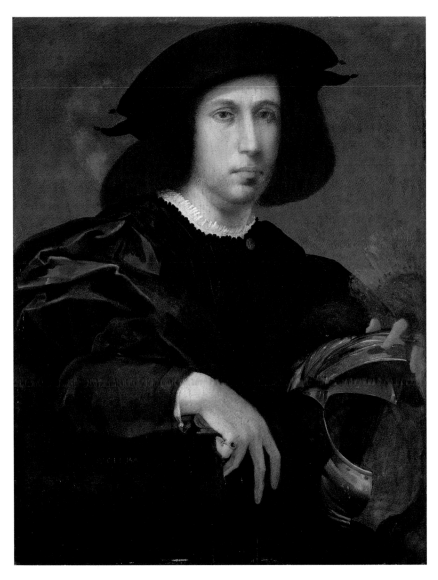

**Giovanni Battista di Jacopo,
called Rosso Fiorentino (1494-1540)
Italian**
Portrait of a young man with helmet,
c. 1522
Panel, 88.6 x 67.3 cm
Formerly in the collection of William
Roscoe.
Presented by Liverpool Royal Institution
1948; inv. no. 2804

Rosso Fiorentino was an expressive
and eccentric exponent of early
Florentine Mannerism which was
opposed to the balanced classicism of
the Renaissance. The painting is
signed with the Latin form of Rosso's
name - Rubeus - which probably
referred to the artist's red hair.

Landscape was one of the main genres of painting to develop in the seventeenth century. Poussin's *Landscape with the ashes of Phocion* and the Dutch artist Ruysdael's *Landscape with a ferry boat* provide contrasting essays in landscape style - from Poussin's monumental austerity to Ruysdael's breezy naturalism. Two smaller cabinet paintings also show dissimilar styles. The lyrical landscape captured in the background of Elsheimer's *Apollo and Coronis* is enlivened with bright specks of paint suggesting beams of light skimming the tree tops and reflected in the pool. Rosa's *Landscape with a hermit* was painted in the 1660s when the artist showed a growing sensibility to nature in its wilder aspects. His original contribution to landscape painting was the prominence given to setting, which often overwhelms the figures. Rosa's paintings became particularly popular among British collectors in the eighteenth century, who especially appreciated savagery in landscape.

Another seventeenth-century artist whose sentiment was particularly appreciated by British artists and collectors of later centuries was the Spanish painter Murillo. He was particularly admired for his mellow colouring, soft handling of paint and his charmingly tender representations of children all of which chimed in well with the taste of the late eighteenth century and the first half of the nineteenth century.

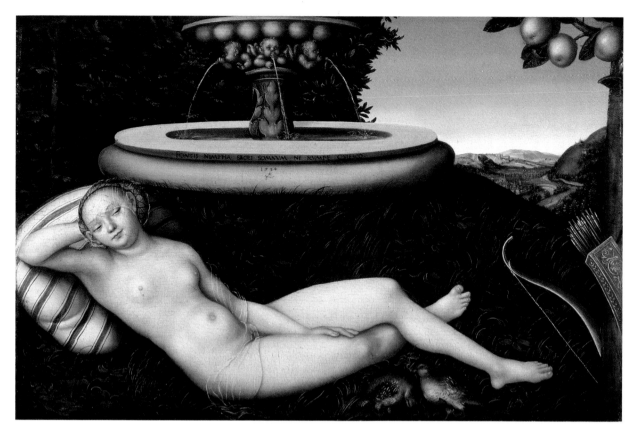

Lucas Cranach the Elder (1472-1553)
German
The Nymph of the fountain, 1534
Panel, 51.3 x 76.8 cm
Presented by the Liverpool Royal Institution, 1948;
inv. no. 1223

The artist received his surname from his native city in
Germany, where his father also worked as a painter. In
1505 Cranach moved to the court of the Elector
Frederick the Wise in Saxony where he established a
large workshop including his sons as assistants. The
reclining female nude composition, based on an ancient
text describing a fountain or spring guarded by a statue
of a nymph, was repeated several times in Cranach's
workshop. The Latin inscription on the fountain repre-
sents the lasciviously smiling nymph's words as she looks
out at us through half-closed eyes: 'I, the nymph of the
sacred fountain, am resting; do not disturb me'. This
seductive nude characterises Cranach's mature style.

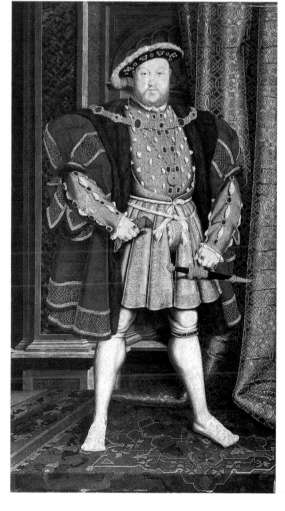

Follower of Hans Holbein (1497/8-1543)
German
Portrait of Henry VIII, after 1537
Panel, 239 x 134.5 cm
Bequeathed by Lord Wavertree, 1945;
inv. no. 1350

Holbein, Henry VIII's court painter, created this
archetypal image for part of a wall-painting in
Whitehall Palace (destroyed 1698). This later copy
was owned by the Seymour family. The innovative
standing pose and the detailed observation of
sumptuous costume and setting convey a powerful
message of strength and majesty.

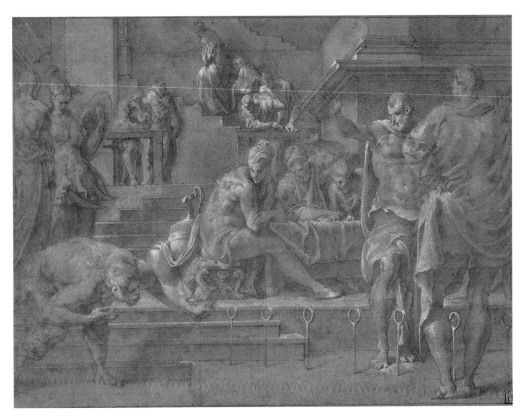

Francesco Primaticcio 1504-70
Italian
Ulysses shooting through the rings, 1555-59
Red chalk and white heightening on pink pre-
pared paper, 24.3 x 32.4 cm
Formerly in the collection of William Roscoe.
Purchased 1991 with the aid of the National
Art Collections Fund; inv. no. 10843

This finished drawing is a preparatory study for
one of the 59 frescos relating the adventures of
Ulysses which were painted on the walls of the
Ulysses Gallery at Fontainebleau Palace. The
drawing fulfilled both a practical function, pro-
viding instructions to Primaticcio's assistants,
and an aesthetic role as an art object.
Primaticcio's skill as a draughtsman and the
drawing's beauty attracted artists and connois-
seurs. The drawing was owned both by the
painter, Joshua Reynolds, and by the Liverpool
collector, William Roscoe.

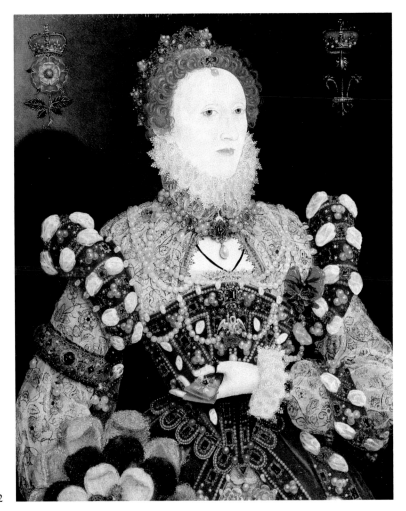

Attributed to Nicholas Hilliard (1547-1619)
English
Queen Elizabeth I - 'The Pelican Portrait', c. 1574
Panel, 78.7 x 61 cm
Presented by E. Peter Jones 1945; inv. no. 2994

In this portrait of the queen, aged about 41,
she is treated almost like a religious icon.
Elaborate symbolism and rich detail show off
her status and queenly qualities, while her fig-
ure is stylised and her face mask-like. The
mother pelican on her brooch is a traditional
Christian symbol of Christ's sacrifice. It was
believed that the pelican fed her young with her
own blood - here it refers to Elizabeth's role as
mother of her people. Hilliard was miniature
painter to Elizabeth. This work relates closely
to his miniature portrait of 1572, but might be
by a follower using Hilliard's designs.

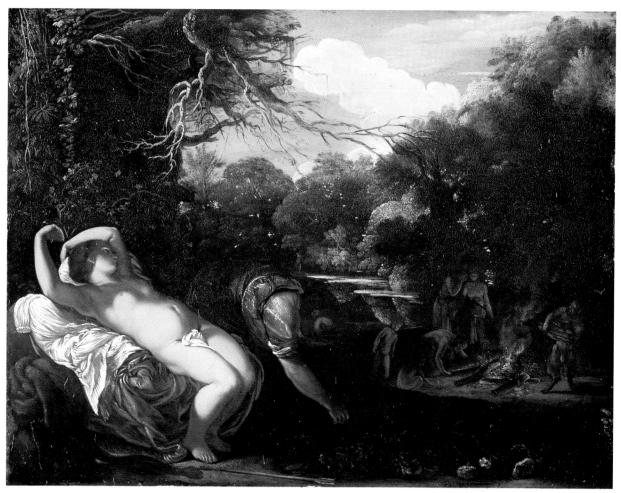

Adam Elsheimer 1578-1610
German
Apollo and Coronis, c. 1607-9
Copper, 17.9 x 23 cm
Presented by H.M. Government 1982 from the
estate of the 4th Baron Methuen; inv. no. 10329

Elsheimer was one of the most inventive artists on a
small scale. His intricate compositions painted on
copper inspired others, including Rembrandt and
Rubens. This picture was reproduced in an engraving
dedicated to Rubens, Elsheimer's friend. As was
often the case with Elsheimer his landscape mirrors
and develops the subject's mood: the god Apollo
picks medicinal herbs in a futile attempt to revive his
unfaithful lover whom he had shot.

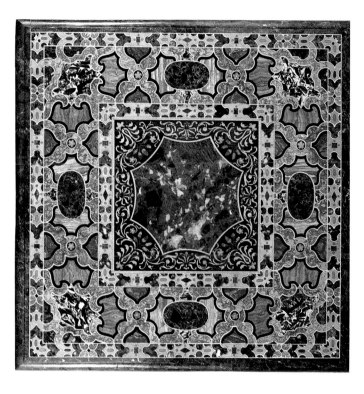

Italian (probably Rome)
Table, c. 1600
Marble and pietra dura top; painted walnut and lime
base, top 120.5 cm square
Purchased 1991 with the help of the National Art
Collections Fund; inv. no. 10839

Furniture inlaid with pietra dura (hardstone) was a
perennial favourite with English visitors to Italy.
This table was bought in the 19th century by Charles
Winn or his son Rowland, first Lord St Oswald, for
Nostell Priory, Yorkshire.

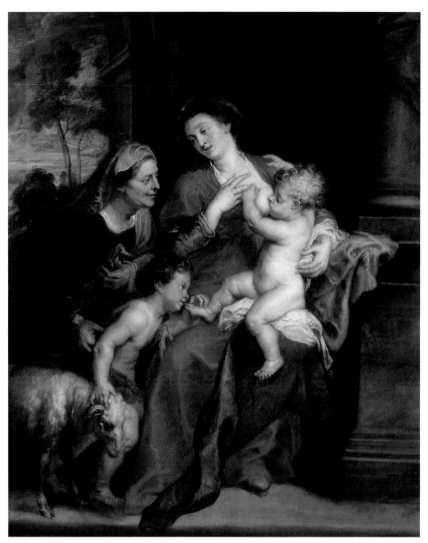

Peter Paul Rubens (1577-1640)
Flemish
*The Virgin and Child with St Elizabeth
and the Child Baptist*, 1630-35
Canvas, 180 x 139.5 cm
Purchased 1960 with the help of the
National Art Collections Fund;
inv. no. 4097

Between 1600 and 1608 Rubens visited
Italy and Spain. On his return to
Antwerp he was immediately recognised
as the most distinguished master in
Flanders and was made court painter to
Archduke Albert, Regent of the
Netherlands. He acted as artistic and
diplomatic ambassador to the Archduke
helping to conduct peace talks between
England and Spain. The two children
may have been modelled on his own
sons by his second wife, Helena
Fourment, whom he married in 1630.
Many copies and variations as well as
engravings of this subject by Rubens
attest to its enormous popularity.

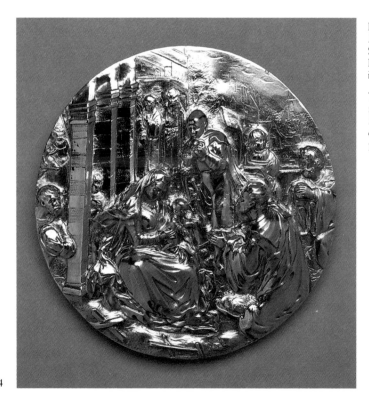

Flemish
Plaque, 1600-25
Silver-gilt, diameter 12 cm
Purchased 1990;
inv. no. 1991.22

The delicate chasing of the metal
represents the *Adoration of the
Magi*. The plaque was probably the
centre of a larger piece of display
plate such as a rosewater dish.

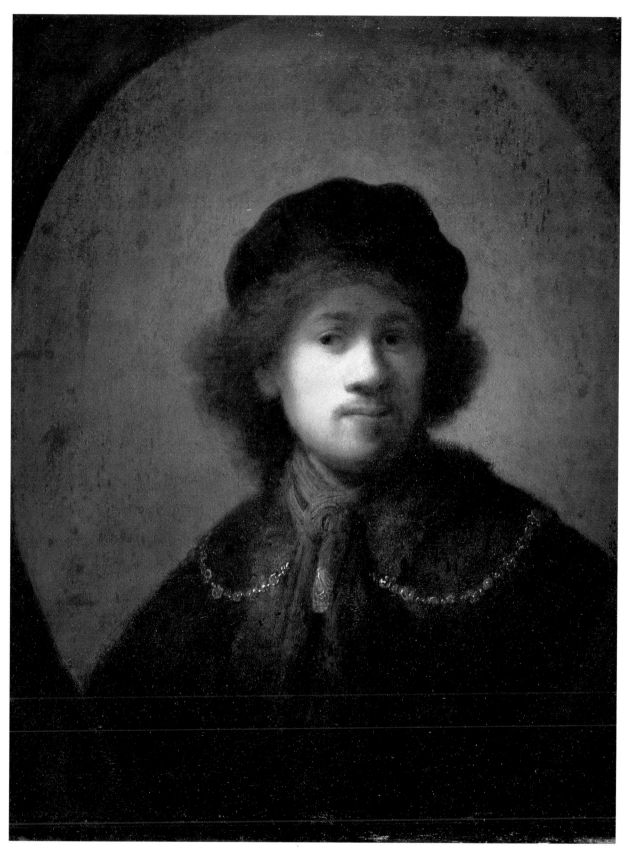

Rembrandt Harmensz. van Rijn (1606-69)
Dutch
Self-portrait as a young man, c. 1630
Panel, 69.7 x 57 cm
Presented by the Ocean Steam Ship
Company acting as Trustees of certain
funds 1953; inv. no. 1011

Rembrandt used his early self-portraits to explore the effects of light and to experiment with facial gesture. This self-portrait was the first painting by Rembrandt to enter a British collection. It was presented to King Charles I in the early 1630s by one of his courtiers, Sir Robert Kerr, Earl of Ancrum, who had acquired it after a diplomatic visit to the Hague in 1629. The painting remained in the palace at Whitehall until the sale of the royal collection after the king's execution.

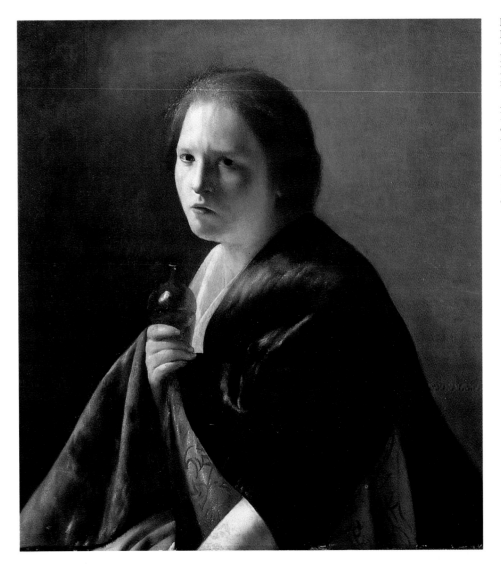

Paulus Bor (about 1600-69)
Dutch (Amersfoort)
The Magdalen, c. 1630-39
Panel, 65.7 x 60.8cm
Purchased 1952;
inv. no. 958

Although a contemporary of
Rembrandt's, Bor favoured a
different painting style
which blended dramatic
light effects, which he had
learned from Caravaggio's
work during his stay in
Rome in the 1620s, with
classical formalism.

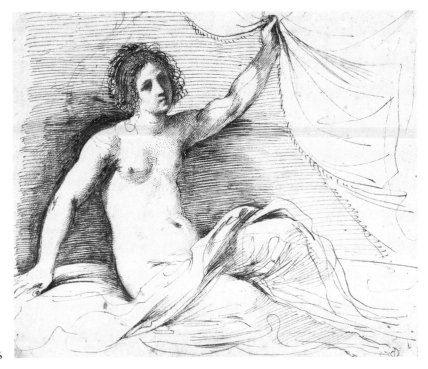

Giovanni Francesco Barbieri called
Guercino (1591-1666)
Italian
Nude holding a curtain, c. 1634
Pen and ink, 20.3 x 24.3 cm
Purchased from Holkham Hall with the
help of the National Art Collections
Fund 1992;
inv. no. 10849

The drawing was probably intended as a
preparatory study for a painting, per-
haps of Venus or another mythological
lover. It may have been connected with
the picture of Mars, Venus and Cupid of
1634 in the Galleria Estense at Modena.
Guercino was one of the most accom-
plished draughtsmen of his time and was
enthusiastically collected by connoisseurs
throughout Europe.

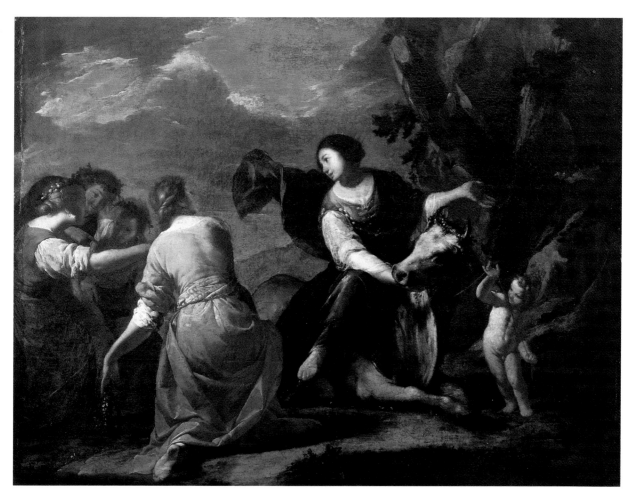

Bernardo Cavallino (1616-56)
Italian (Naples)
The Rape of Europa, c. 1642
Canvas, 101 x 133.7 cm
Presented by T.A. Hope 1882; inv. no. 2771

The princess Europa is shown seated on a bull, the mythological god Jupiter in disguise, who is about to abduct her. Most of Cavallino's paintings of scriptural and literary subjects were probably intended for cultivated private patrons.

Jusepe de Ribera (1590-1652)
Spanish (Naples)
The Adoration of the shepherds,
c. 1640-49
Black and red chalk with brown and black wash on paper, 16.5 x 19.5 cm
Purchased from Holkham Hall with the help of the National Art Collections Fund and the Foundation for Sport and the Arts 1992; inv. no. 10851

Ribera lived most of his artistic life in Naples where he prospered as painter to the region's Spanish viceroys and religious institutions. The fine drawing which deftly combines coloured chalks with washes is not related to a known painting, although the theme was a favoured one of Ribera's in the 1640s.

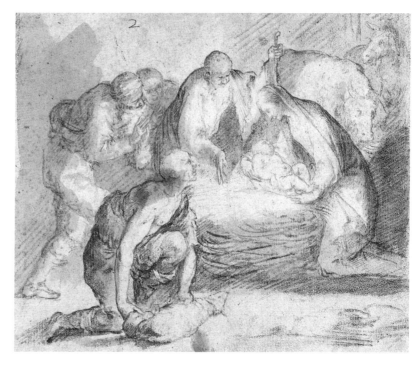

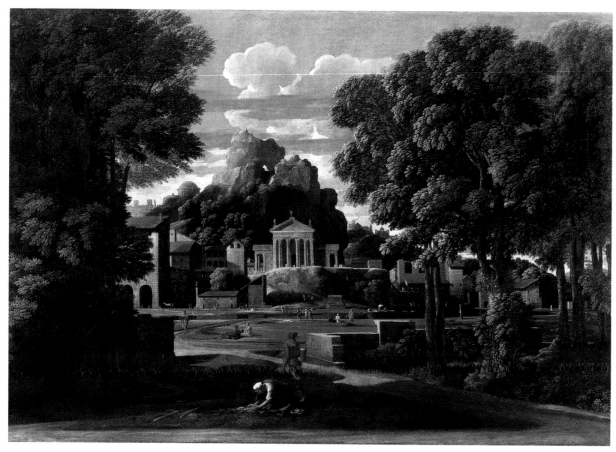

Nicolas Poussin (1593/4-1665)
French
Landscape with the ashes of Phocion,
1648
Canvas, 116.5 x 178.5 cm
Purchased with the help of the National Art Collections Fund and the National Heritage Memorial Fund 1983; inv. no. 10350

Phocion was a great Athenian general and statesman of the 4th century B.C. He was executed for treason on a false charge contrived by his political enemies and his body ignominiously ordered out of Athens to Megara where it was burnt. In this painting a woman of Megara is carefully collecting the ashes and performing the appropriate ceremony over them. The solemn grandeur of the subject is conveyed by the rigid structure, the geometrical organisation, the ponderous solidity and the perfect calm of the landscape and townscape. The fluctuations of fortune have led Phocion to an obscure burial in a foreign land but even there his austerity, rectitude and achievements are reflected in a classical, even heroic, setting dominated by the central temple and hill and by the dark massed trees on either side. Poussin turned to landscape in middle age, and this was one of the first of a group which virtually created a new tradition of classical landscape.

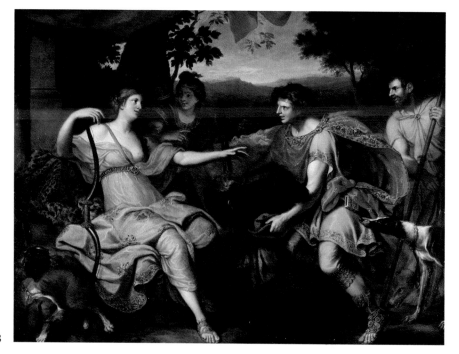

Charles Lebrun (1619-90)
French
Atalanta and Meleager, c. 1658
Canvas, 212.5 x 280.5 cm
Presented by B. Benjamin 1852; inv. no. 2898

This is a cartoon (or preparatory painting) for one of a series of tapestries woven at the Gobelins factory and illustrating the story of Meleager. Meleager killed the huge Calydonian boar which had been devastating his country and here he presents its remains to Atalanta who had first wounded it.

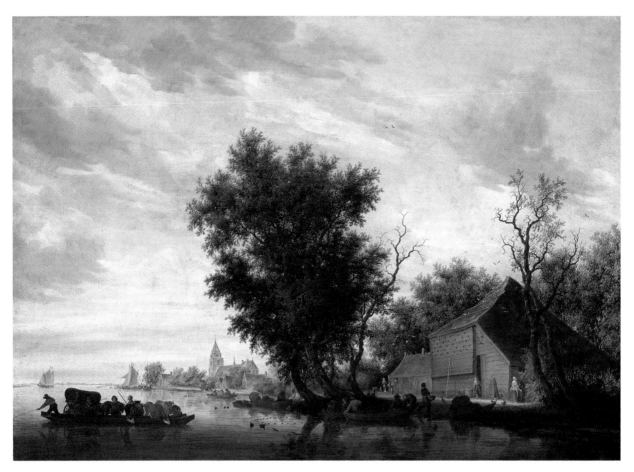

Salomon van Ruysdael (c.1600/02-70)
Dutch (Haarlem)
River scene with a ferry boat, 1650
Canvas, 106 x 152 cm
Bequeathed by E.E. Cook through the
National Art Collections Fund 1955;
inv. no. 1022

Salomon van Ruysdael came from a family of
artists, but little is known of his training. His
paintings represent a calm, luminous world.
Ruysdael was not concerned with producing
a topographically exact view. Instead he
brought together elements characteristic of
the Dutch countryside to form an ideal yet
naturalistic-looking landscape.

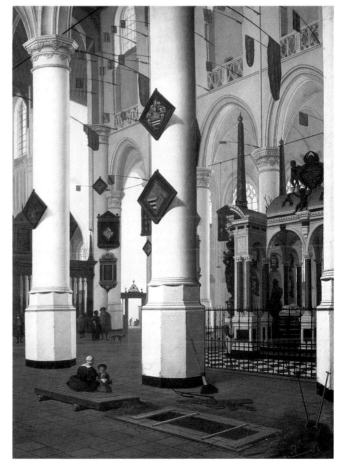

Hendrik Cornelisz. van Vliet (1611/12-75)
Dutch (Delft)
The New Church at Delft with the tomb of William of
Orange, 1667
Canvas, 127 x 85.5 cm
Purchased with the help of the National Art Collections
Fund 1994; inv. no. 1994.1

Van Vliet specialised in views of the interiors of Delft's
two main churches, the Old and the New Church. The
New Church housed the tomb of the assassinated Dutch
hero William I of Orange ('the Silent') (1533-84) who
helped establish the independence of the Netherlands
from Spanish rule.

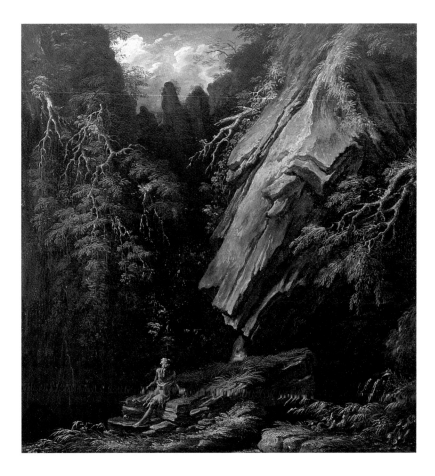

Salvator Rosa (1615-73)
Italian (Naples, Florence, Rome)
Landscape with a hermit, c. 1667
Canvas, 78.8 x 75.5 cm
Presented by Miss G I Anson 1933;
inv. no. 2891

Rosa painted several hermit pictures in the
1660s at a time when he was increasingly
seeking solitude. In 1662 while travelling
through the Appennines to visit the Holy
House of Loreto and Assisi he was struck
by the picturesque quality of the mountain-
ous landscape.

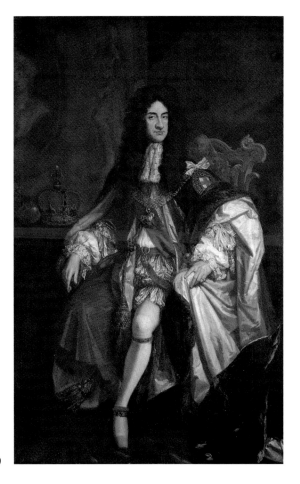

Godfrey Kneller (1646-1723)
German
King Charles II, 1685
Canvas, 224.5 x 143 cm
Purchased 1952;
inv. no. 3023

Kneller came to England in
1676 and soon gained royal
favour. Here the king's authori-
ty is subtly undermined: his face
is stiff, his hand limp, and the
crown and the orb are hidden in
shadow. Kneller presents an
ageing and even lonely figure.
This is the last of his portraits of
Charles II, probably begun just
before the king's death and fin-
ished afterwards.

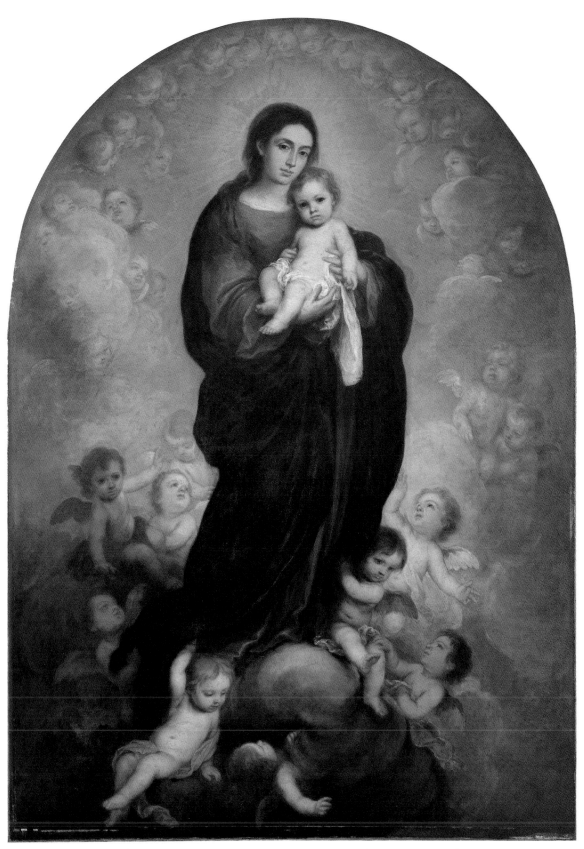

**Bartolomé Esteban Murillo
(1618-82)**
Spanish (Seville)
Virgin and Child in Glory, 1673
Canvas, 236 x 169 cm
Presented by the National Art
Collections Fund 1953;
inv. no. 1351

This altarpiece was commissioned by Ambrosio Ignacio Spínola y Guzmán, Archbishop of Seville (1670-84), along with a series of seven paintings of *The life of St Ambrose* by Valdés Leal, for the archbishop's private chapel in his Seville palace. Spínola chose the most important religious artist in Spain to paint this grand but intimate image. During the Spanish Peninsular War (1808-14) the palace was the headquarters of the French marshal Soult, who took the altarpiece with him as war booty to France without the central area of the canvas showing the appealing faces of the Virgin and Child. The two separated parts were not reunited until they were acquired by the British collector, Lord Overstone. 41

Rococo, Classicism & Romanticism

Liverpool's growth from a minor estuary port to England's second city, which took place in the eighteenth and early nineteenth centuries, was matched by her development into one of the country's most significant provincial artistic centres. Outside the city, local landed patrons such as the Earls of Derby and Henry Blundell of Ince perpetuated an essentially aristocratic taste; but the access of mercantile wealth led to the emergence of both a new collector class and a local school of artists comparable to those which flourished in Norwich and Bristol. By the 1820s the Liverpool Academy, first mooted only a year after the foundation of the Royal Academy in London, was firmly established, while the depth and vitality of picture collecting in the city at this time can be gauged, for example, by the Royal Institution's Old Masters exhibition in 1823. The twenty-six eighteenth-century British pictures included in this show provide a fascinating anticipation of later civic taste in works of the national school: the Grand Style, a handful of landscapes by Wilson excepted, is conspicuously absent, and the rustic and fanciful predominates, from smugglers and gypsies by Morland and Loutherbourg to the essentially provincial visions of Wright of Derby, among which was a version of his *Girandola at the Castel Sant' Angelo*.

The gallery's own *Girandola*, presented in 1880, was almost the first significant eighteenth-century British painting to enter the collection. From then until the First World War, acquisitions in that sphere were dominated by the early Liverpool school and artists with strong local or north western connections such as (Wright apart) John Rathbone ('the Manchester Wilson') and George Stubbs. The purchase of Stubbs's *Horse frightened by a lion* in 1910 was by far the gallery's outstanding achievement with eighteenth-century British art for the best part of sixty years. The great market boom in later Georgian art, so significant an element in the creation of the Lady Lever Art Gallery in Port Sunlight, was not very apparent in the development of the Walker where figures such as Reynolds - and also Constable and Turner - were represented for years by pastiches or even forgeries.

After the First World War early British art continued to be neglected until a watershed was reached in 1935. The purchase in that year of Richard Wilson's masterpiece *Snowdon from Llyn Nantlle* marked the gallery's recognition that its holdings of 'classic' British art were inadequate, and the start of a policy of purchasing representative works by most of the leading eighteenth-century names. In the next twenty years, the Walker sought out first-rate examples of the conversation piece (by Devis, Zoffany and Gawen Hamilton); the society portrait (Ramsay, Cotes, Highmore); a classic horse-portrait by Stubbs (*Molly Longlegs*) and finally a magnificent example of that quintessentially British genre, the theatrical portrait, Hogarth's *David Garrick as Richard III*. Also in the same period were added representative seventeenth- and early eighteenth-century works (Johnson, Dobson, Lely, Kneller, Dahl) and museum-quality works by Constable and Turner.

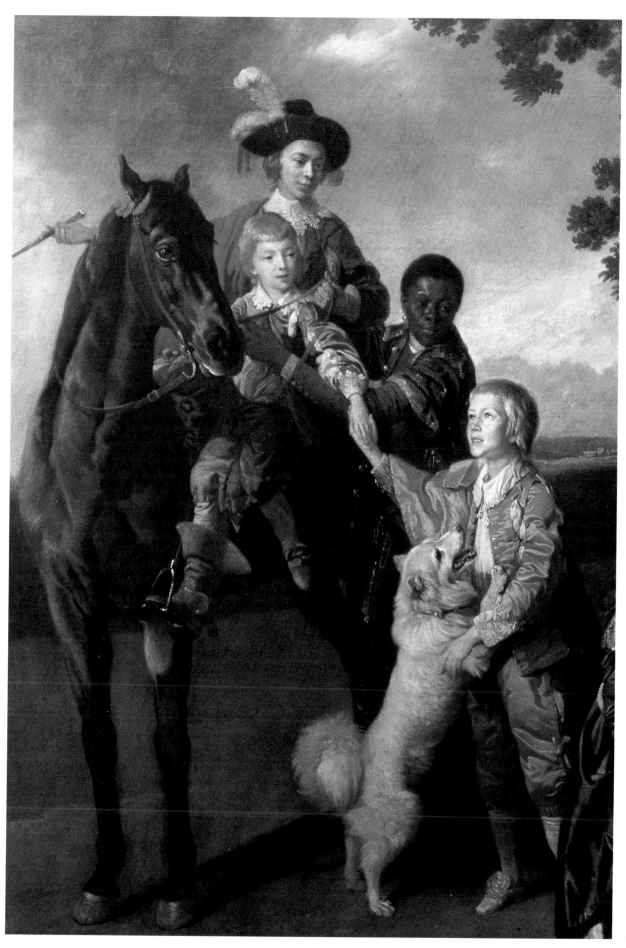

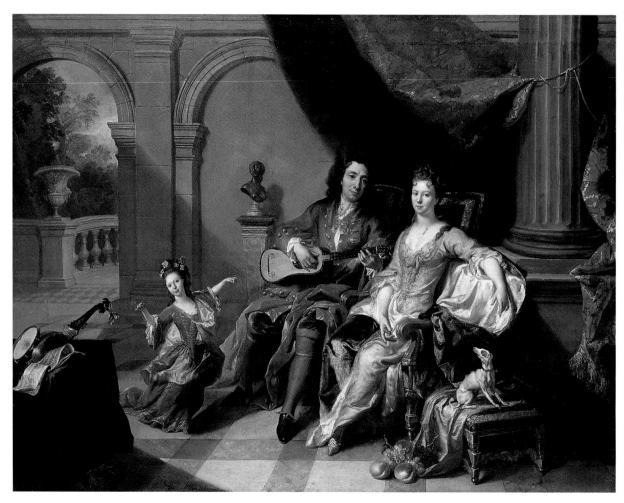

Jacob van Schuppen (1670-1751)
French (Paris, Vienna)
The Guitar player, c. 1700
Canvas, 90.2 x 117.5 cm
Presented by the Liverpool Royal Institution,
1948; inv. no. 1195

Charmingly informal, this is probably a portrait of a French courtier and his family painted before the artist left Paris in 1706-7. The guitar was popular at the French court in the early 18th century and was considered especially suitable for accompanying singing: the music book on the table appears to be open at a song. The prominence given to music making is perhaps meant to suggest harmony within the family.

This twenty year period in mid-century provided an essential platform for the gallery's most recent phase of collecting eighteenth- and early nineteenth-century art, in which specialist bias has replaced the search for the representative. Major works which nevertheless possess a local significance and enhance our understanding of Liverpool culture in the period have dominated acquisitions over the last thirty years. Notable amongst them are the great Gainsborough full-length of the first Countess of Sefton, portraits made in Liverpool by Wright of Derby and (remarkably) George Stubbs, and sculpture by the great Liverpool-trained neo-classicist John Gibson, together with works by his followers. The effects of this latest phase have been not only to reinforce quality, but also to set in renewed relief some of the tensions to be felt in Liverpool as a provincial cradle of art in a dynamic period of creative endeavour.

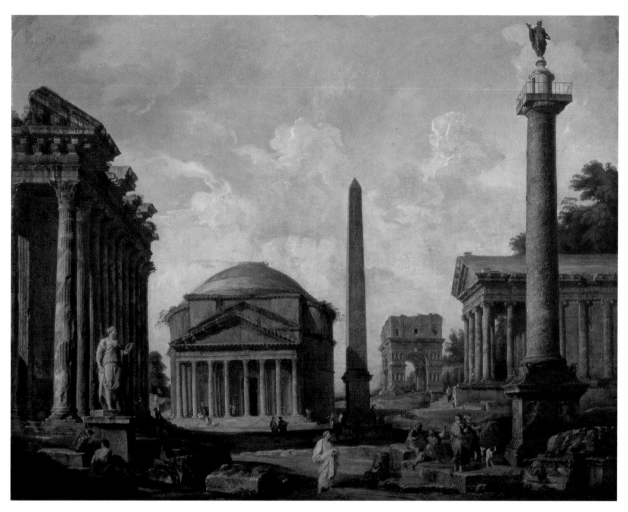

Giovanni Paolo Panini (1691/2-1765)
Italian
Ruins of Rome, c. 1741
Canvas, 173 x 221 cm
Presented by James Aikin 1876;
inv. no. 2794

Panini had a flourishing practice in Rome
providing 18th-century Grand Tourists
with souvenir composite views or capricci,
like this of the most important ancient
buildings in the city. Here are included
Trajan's Column, the Pantheon and the
Temple of Fortuna Virilis.

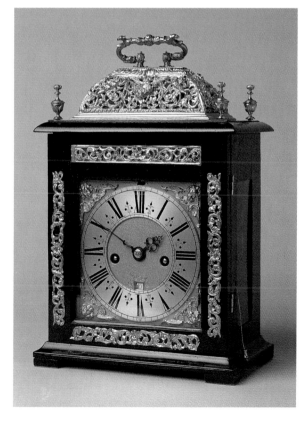

Daniel Quare (1649-1724)
English
Spring Clock, c. 1720
Ebony on oak case, gilded brass decoration,
brass and steel movement, 33 x 22.5 x 14.5 cm
Purchased 1968;
inv. no. 1968.250

The striking movement has repeating work that will sound the time
to the nearest quarter hour on two bells. Quare was one of the
great clockmakers of his day; he invented repeating work for
watches in about 1680.

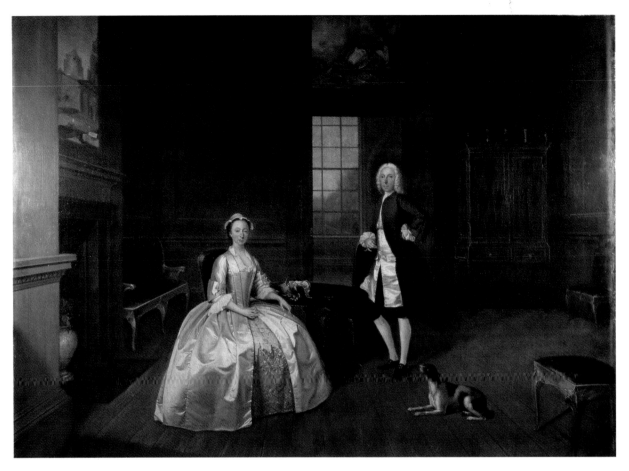

Arthur Devis (1711-82)
English
Mr and Mrs Atherton, c. 1743
Canvas, 92 x 127 cm
Purchased 1940; inv. no. 1353

This portrait was once thought to have commemorated the couple's marriage in 1730, but is now believed to date from the following decade. William Atherton (died 1745) was sometime Alderman and Mayor of Preston, and a friend of the artist's father. Conversation pieces - family group portraits in an informal, domestic setting - were a distinctive feature of 18th-century British painting. The furniture shown in this work was almost certainly the Athertons' own; but the rather palatial room and grand garden are probably inventions, designed to exaggerate their social standing.

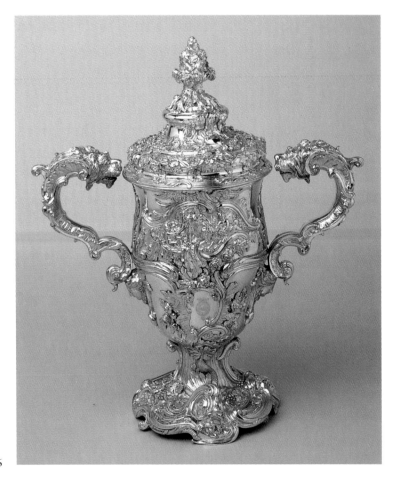

Lewis Pantin
English
Two-handled cup, 1744
Silver gilt, height 38 cm
Bequeathed by Lord Wavertree 1933;
inv. no. 3318

Made for display on a dining-room sideboard, this cup is fashioned in the swirling and asymmetrical rococo style.

46

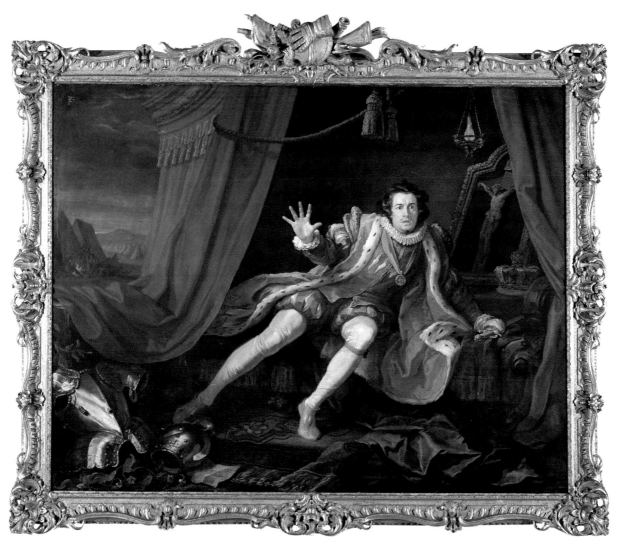

William Hogarth (1697-1764)
English
David Garrick as Richard III, 1745
Canvas, 190.5 x 250.8 cm
Purchased with the help of the National Art Collections Fund 1956;
inv. no. 634

David Garrick (1717-79) was the greatest British actor of the mid-18th century. He became famous from 1743 after his outstanding performance as Shakespeare's Richard III. He is shown here in the famous tent scene before the Battle of Bosworth, haunted by the ghosts of all those he had murdered. Garrick's body is contorted into a 'serpentine' line - a stretched 'S' shape that Hogarth considered was distinctly beautiful and which he later made the basis of his theoretical treatise *The Analysis of Beauty* published in 1753. This first major Shakespearian picture is not just a portrait but also a grand history painting in which Hogarth emphasises England's importance: he believed that an incident from English history rather than ancient history could still be used to teach a moral lesson.

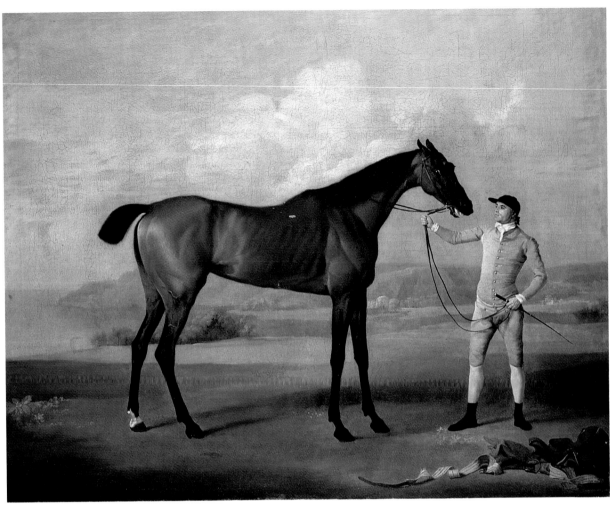

George Stubbs (1724-1806)
English
Molly Longlegs, 1762
Canvas, 101 x 126.8 cm
Presented by Lewis's Department Store, Liverpool 1951;
inv. no. 2389

Liverpool-born George Stubbs, the outstanding animal
painter of the 18th century, gained an international reputa-
tion with the publication in 1766 of his *Anatomy of the
Horse*. This picture with its clear depiction of veins, bones,
muscles and distinctive equine bloodpoints is among the best
of his single horse portraits and indicates well how closely
Stubbs's anatomical studies and portraiture interlinked.
Molly Longlegs was a bay mare, who twice won 200 guinea
prizes at Newmarket. She belonged to Lord Bolingbroke who
probably commissioned the picture.

Joseph Wright of Derby (1734-97)
English
Richard Gildart, 1768
Canvas, 125 x 100 cm
Purchased 1988;
inv. no. 10637

Wright worked as a portraitist in Liverpool between 1768
and 1771. His presence had an enormous impact on the local
art scene and his works of this period reflected and helped to
define taste in a burgeoning mercantile city. Gildart was one
of Liverpool's most remarkable citizens: a merchant in the
sugar trade all his life, Mayor three times, member of parlia-
ment for nearly twenty years; and here ninety-five years old.
Wright's formidable portrait is unflinching in its directness.

Richard Wilson (1713-82)
Welsh
Snowdon from Llyn Nantlle, c. 1765
Canvas, 101 x 127 cm
Purchased 1935;
inv. no. 2429

Wilson became a seminal figure in British landscape painting as the first native artist who convincingly straddled the gap between the academic landscape and the topographical view. His models were the French classicists, notably Gaspard Dughet and Claude Lorrain, whose concern for the essential structure of the landscape, whose sense of order, and whose feeling for a beautiful, all-over light are echoed in this masterpiece. With these precepts, however, Wilson has fused a marvellous sensitivity to locale: that concern for the particular in nature which became so important to the Romantics. Wilson's unerring sense of design and tonal value invests the rugged grandeur of his native Welsh mountains with a luminous and timeless repose.

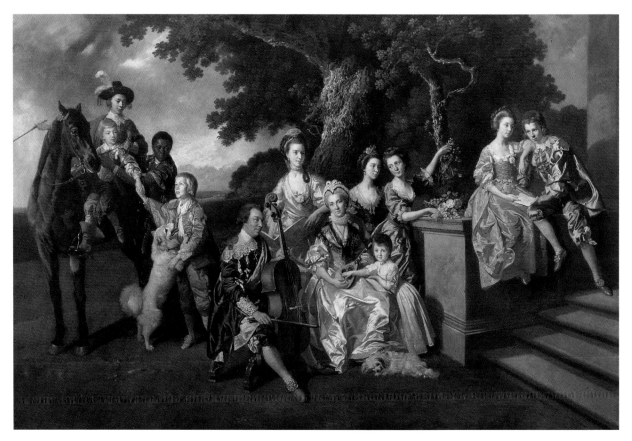

Johan Zoffany (1734/5-1810)
German
The Family of Sir William Young, c. 1770
Canvas, 114.3 x 167.8 cm
Purchased 1937;
inv. no. 2395

Usually dated to 1770 when Sir William Young (1725-88) obtained his baronetcy and was appointed Governor of Dominica. All the family wear theatrical Van Dyck costume, then very fashionable particularly in portraits. Musical instruments suggest the family enthusiasm for music. The black servant or slave evokes their West Indian sugar plantations.

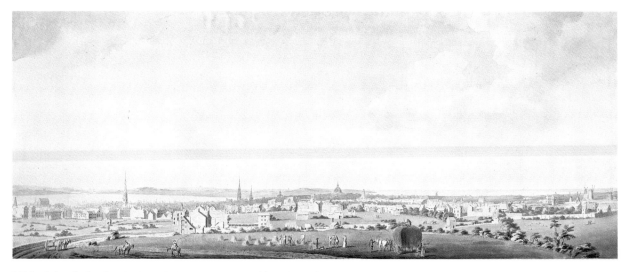

Michael Angelo Rooker (1746-1801)
English
Liverpool from the Bowling Green, 1769
Watercolour on paper, laid on card, 31.4 x 76cm
Purchased 1974;
inv. no. 8654

Although Rooker specialised in topographical watercolours his usual subjects were country towns or medieval ruins in rural settings. This view of a modern, expanding port is unusual in his work. The spires and domes of churches and public buildings - and the forest of masts in the docks - show the prosperity of 18th-century Liverpool, but the surrounding fields still allow for a conventionally pretty rustic foreground.

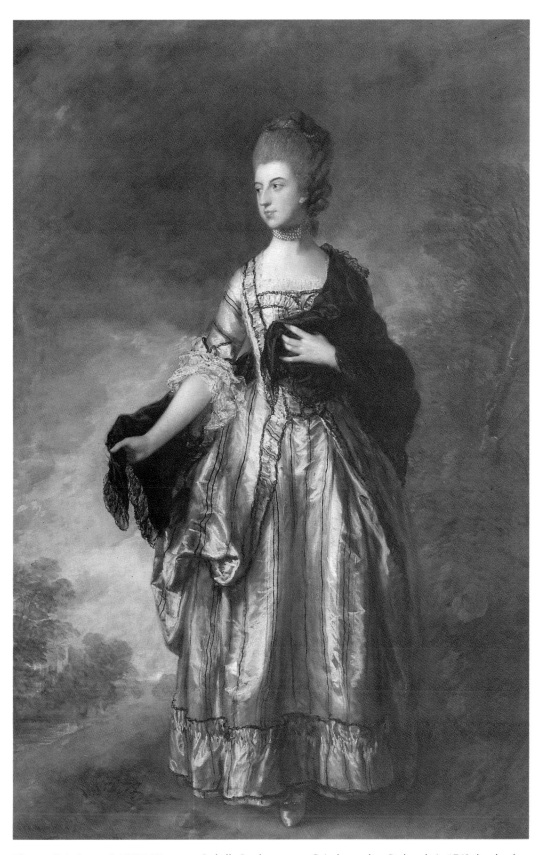

Thomas Gainsborough (1727-88)
English
Isabella, Viscountess Molyneux, later
Countess of Sefton, 1769
Canvas, 236 x 155 cm
Presented by H.M. Government from
the estate of the 7th Earl of Sefton;
inv. no. 8780

Isabella Stanhope sat to Gainsborough at Bath early in 1769 shortly after
her marriage to Viscount Molyneux. The artist had just been elected to
the Royal Academy in London, and this work, sent soon afterwards to its
first-ever exhibition, surely represents a deliberate effort to impress a
London audience. The figure has a brilliant poise and the play of light
and shade on the satiny surface of her dress is a miracle of virtuoso paint-
ing. Shortly afterwards her husband was created the 1st Earl of Sefton,
and the portrait hung at the Seftons' seat, Croxteth Hall near Liverpool,
for two centuries until its acquisition by the Walker Art Gallery.

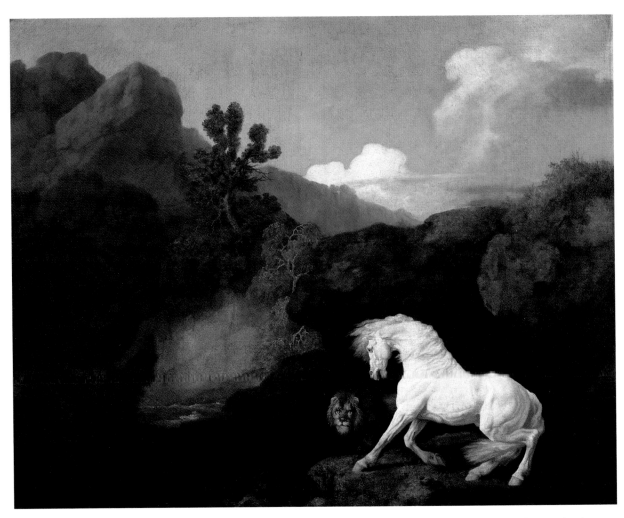

George Stubbs (1724-1806)
English
A Horse frightened by a lion, 1770
Canvas, 100.1 x 126 cm
Purchased 1910;
inv. no. 2387

Stubbs's principal reputation was as a horse portraitist. His aspirations to be considered a painter of loftier subjects probably led to the decision to paint his numerous Lion and Horse pictures. An antique Roman statue in the Palazzo dei Conservatori in Rome showing a lion clawing at a horse's back was seen by Stubbs when he visited the city in 1755 and almost certainly inspired the series. The horse, tense with fear, is depicted with magnificent anatomical precision. By contrast the lion, possibly painted from a skin, looks rather tame.

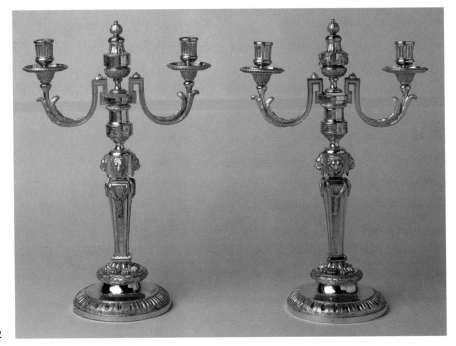

Matthew Boulton (manufacturer)
(1728-1809)
English
Candelabra, c. 1771
Ormolu, height 46 cm
Purchased 1980;
inv. no. 1980.684

Probably one of each of the two pairs of 'lyon-faced' candlesticks bought at the Boulton sale at Christie's in 1772 by the Earl of Sefton. Matthew Boulton at his Soho factory in Birmingham pioneered the manufacture of high-quality gilt bronze, or ormolu, in England.

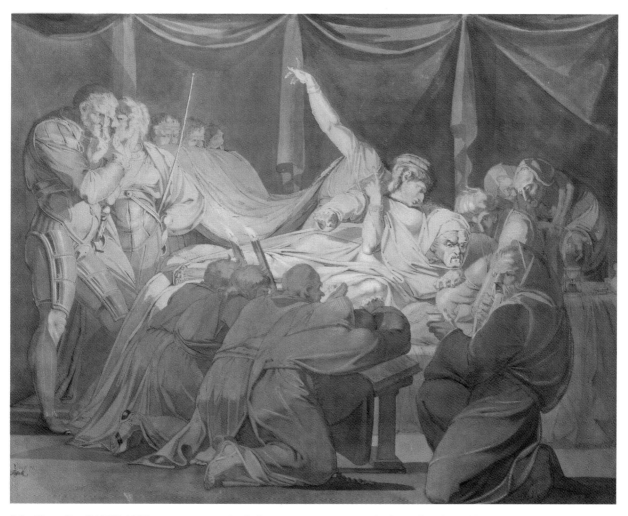

John Henry Fuseli (1741-1825)
Swiss
The Death of Cardinal Beaufort, 1772
Pen, ink, pencil and grey wash on paper,
65 x 81.9 cm
Presented by the Liverpool Royal Institution
1948; inv. no. 1540

In Shakespeare's *Henry VI*, Cardinal Beaufort dies in black despair having been involved in the murder of Humphrey, the good Duke of Gloucester. Fuseli shows the young king, Henry VI, raising his arm and vainly demanding some sign of repentance from the cardinal. The drawing was made in Rome and sent to England for exhibition. It combines Roman neoclassicism - the even lighting, flat composition and figures in rows - with the expressionist violence that was to characterise Fuseli's later more Romantic work.

Gilles Joubert (designer)
French
Commode, 1772
Tulipwood amd marquetry,
91 x 146 x 66 cm
Purchased 1988;
inv. no. 10774

One of a pair supplied by Joubert for the Salon de Compagnie of Mademoiselle du Barry (sister-in-law of Louis XV's mistress Madame du Barry) at Versailles. It is stamped RVLC for Roger Vandercruse Lacroix who manu-factured it to Joubert's design.

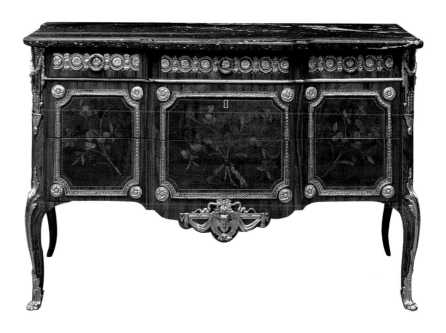

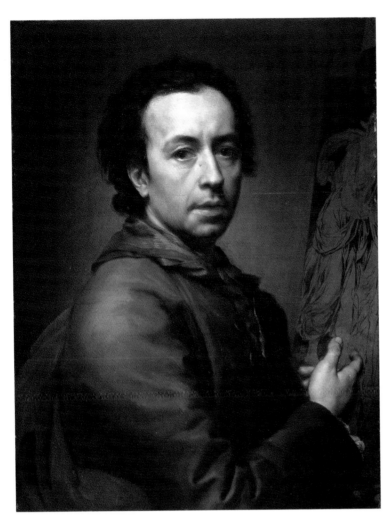

Anton Raphael Mengs (1728-79)
German
Self-portrait, 1774
Panel, 73.5 x 56.5 cm
Purchased 1953;
inv. no. 1227

In the best tradition of artist's self-portraits, this is a work of psychological insight. With the bohemian elegance there is also a sense of weariness - perhaps reflecting the huge demand throughout Europe for Mengs's religious and historical paintings. The artist points to a sketch for one of his last works, *Perseus and Andromeda*. It and this self-portrait were commissions from two of his many British admirers.

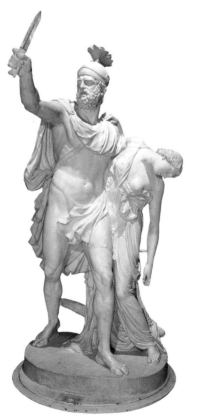

Giacomo de Maria (1762-1838)
Italian (Bologna)
Death of Virginia, c. 1806-10
Marble, height 214 cm
Purchased 1968;
inv. no. 6652

In 5th-century B.C. Rome one of the judges (or decemvirs) conspired with a friend to kidnap and rape Virginia, the daughter of an army officer (or centurion). Her father found her eventually and stabbed her in order to preserve her chastity. Appalled by these events, the Roman people rebelled and abolished the arbitrary power of the decemvirs. The subject suited the revolutionary fervour of Napoleonic Italy and this group was carved largely for the instruction of the students at the Bologna Academy of Fine Art.

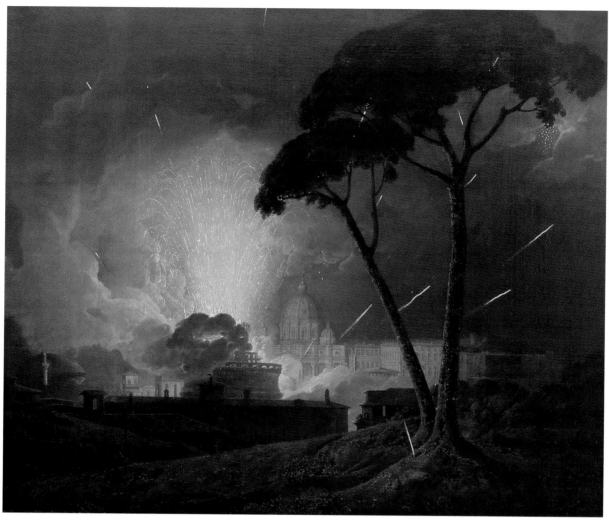

Joseph Wright of Derby (1734-97)
English
The Annual Girandola at the Castel Sant' Angelo, Rome,
1775-76
Canvas, 138 x 173 cm
Presented by Robert Neilson;
inv. no. 1428

Painted shortly after Wright returned from a trip to Italy, this
was paired with the Eruption of Vesuvius: 'the one the greatest
effect of Nature, the other of Art that I suppose can be', he
said. Wright was fascinated all his life with powerful effects of
light and made his name painting them. In his hands, the fire-
work display held in Rome every Easter becomes an almost
apocalyptic vision of the city.

Carlo Albacini (1735-1813)
Italian (Rome)
Bust of Lucius Verus, c. 1777
Marble, height 89 cm
Presented by Colonel Sir Joseph Weld 1959;
inv. no. 6538

Lucius Verus was a Roman Emperor of the 2nd century
noted for his debauchery and profligacy. This is a copy
of an ancient bust now in the Louvre; it was bought
from the artist by Henry Blundell of Ince (near
Liverpool) in 1777. Blundell later formed one of the
largest collections of ancient sculpture ever assembled in
England, but he admired fine 18th-century copies of
classical works just as much as the originals.

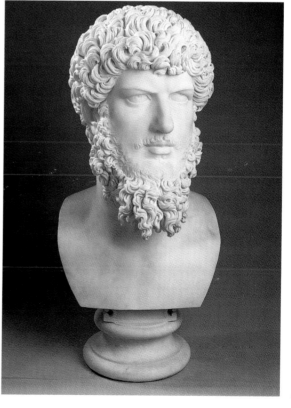

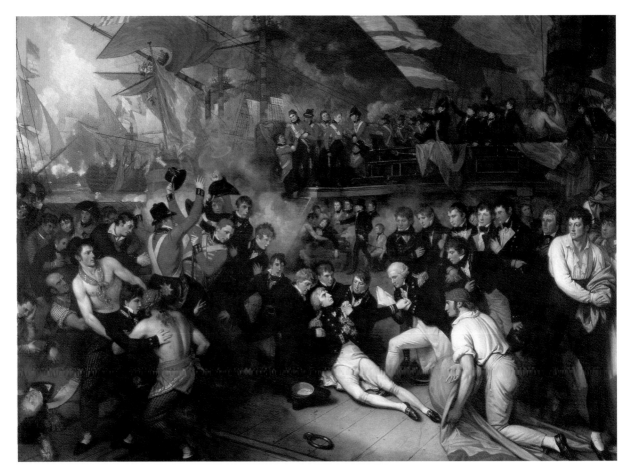

Benjamin West (1738-1820)
American
The Death of Nelson, 1806
Canvas, 182.5 x 247.5 cm
Presented by Bristow H Hughes;
inv. no. 3132

Crowds flocked when West exhibited this painting in his house a few months after the Battle of Trafalgar. Many of the portraits were said to be taken from life, but the event is presented in an idealistic and theatrical manner. The formula is similar to West's famous *Death of Wolfe*, which had revolutionised British history painting over thirty years earlier, but this work never enjoyed the same critical acclaim.

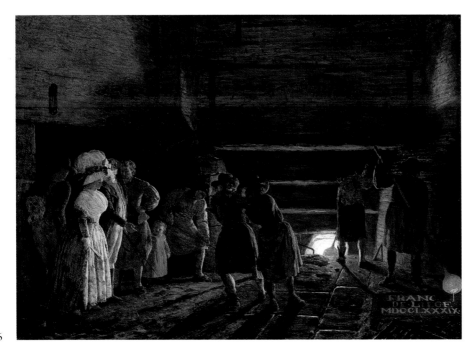

Léonard Defrance (1735-1805)
Belgian (Liège)
Interior of a Foundry, 1789
Panel, 42 x 59.2 cm
Purchased 1990 with the help of the National Art Collections Fund;
inv. no. 10824

Defrance produced several paintings of foundries and forges in his native Liège, a town associated for centuries with metalworking and an important industrial centre by the late 18th century. This example is exceptional for the form of the artist's signature and the date, painted as if they are being cast in glowing molten metal.

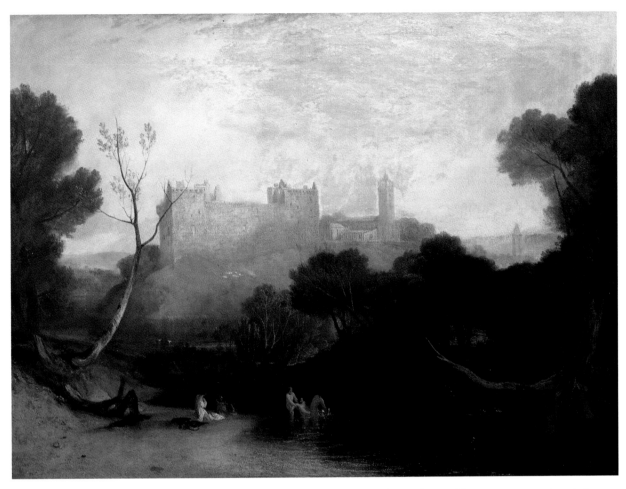

Joseph Mallord William Turner (1775-1851)
English
Linlithgow Palace, 1807
Canvas, 91.4 x 122 cm
Presented from the Nettlefold Collection 1947;
inv. no. 2583

Linlithgow Palace, birthplace of Mary Queen of Scots, was a romantic and pic-
turesque ruin by 1807. Turner added naked nymphs and evenly balanced trees that
have the effect of elevating the picture above simple antiquarian topography into
something closer to a classical history painting in the manner of Claude Lorrain.
The thickly impastoed sunlit clouds, however, betray Turner's fundamental love of
depicting strong natural effects.

Josiah Wedgwood
(manufacturer) (1730-95)
English
Cup and Saucer, c. 1775
Creamware,
diameter 11.8 cm (saucer)
Presented by Joseph Mayer
1867; inv. no. M276

Painted with views of
Hawksmoor's mausoleum at
Castle Howard (cup) and Stoke
Gifford (saucer). In 1774
Wedgwood made a service
painted with English views, for
Empress Catherine of Russia.
These pieces are among the few
other examples decorated in the
same manner.

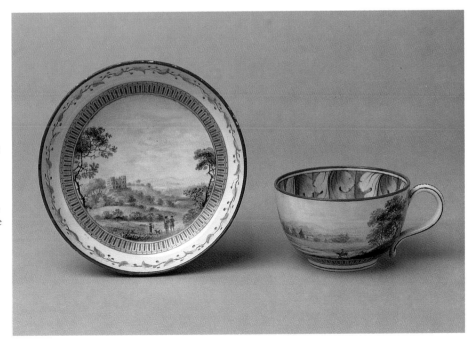

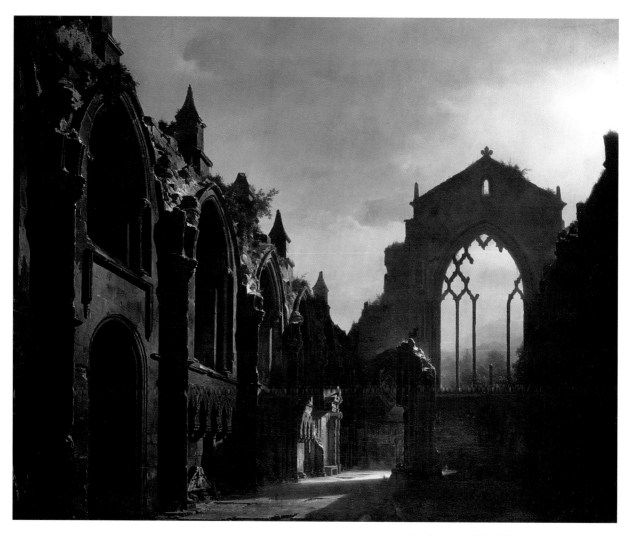

Louis Jacques Mandé Daguerre (1787-1851)
French
The Ruins of Holyrood Chapel, c. 1824
Canvas, 211 x 256.3 cm
Presented by Arnold Baruchson 1864;
inv. no. 3034

Daguerre specialised in painting dioramas;
these were realistically painted and illuminat-
ed giving a three dimensional effect and
showing famous scenes or events. In this
painting we see a dramatic illusion of the
chapel ruins by moonlight. The picture has an
almost cinematic impact reflecting Daguerre's
dioramas. Later in life Daguerre experiment-
ed with photography. In 1839 he invented
one of the first photographic processes, the
daguerrotype.

George Bullock (1782/3-1818)
English
Pair of Candelabra, 1814-18
Marquetry of rosewood and brass, with ebonised wood
mouldings and gilt metal mounts, height 198 cm
Purchased with the help of the National Art Collections Fund
1989; inv. no. 10781-2

Bullock was based in Liverpool between 1804 and 1814.
These candelabra were probably made after his move to
London. They were purchased at the sale following his sud-
den death by Sir William Gordon Cumming. They would
have supported candles or, more probably, oil lamps.

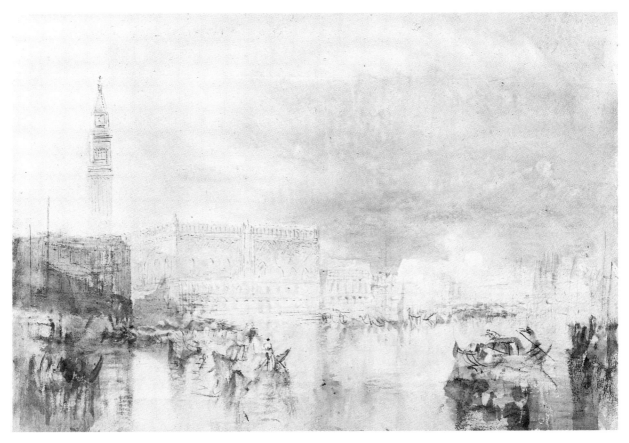

Joseph Mallord William Turner (1775-1851)
English
Venice, 1840
Watercolour on paper, 22.2 x 32.3 cm
Presented by R.R. Meade-King 1934;
inv. no. 999

One of a number of the limpid aquatic views
of Venice from the so-called 1840 'Roll
Sketchbook' that perfectly reveal Turner's
commanding skill in old age as a water-
colourist. Painted wet-on-wet, with subtrac-
tions of paint using sponge and scratching,
the final summary surface notations are in
rapidly applied red penstrokes.

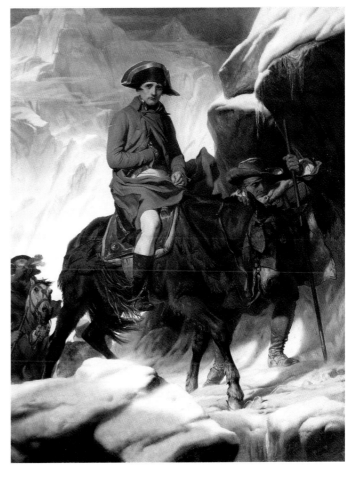

Paul Delaroche (1797-1856)
French
Napoleon crossing the Alps, 1850
Canvas 279.4 x 214.5 cm
Presented by Henry Yates Thompson 1893;
inv. no. 2990

In the summer of 1800 Napoleon with a modest army
advanced into Italy and only about six weeks after leav-
ing Paris totally defeated the Austrians at Marengo.
Delaroche has selected from this great military campaign
a very unremarkable incident - the Emperor crossing the
Great Saint Bernard Pass on a mule borrowed from a
local inhabitant and led by a Swiss peasant. In 1801
Jacques Louis David had painted a great flamboyant
official portrait of Napoleon crossing the Alps on a rear-
ing horse pointing at the sky with his cloak swirling
around him in the wind. Delaroche's literal accuracy
and careful detail - even in for example, the mule's har-
ness - shows the gradual development of realism in the
19th century.

Victorian Art

The Walker Art Gallery was founded in 1873 primarily to display and collect art of that period, and it is not therefore surprising that high and late Victorian art is represented there splendidly and comprehensively with a strong international flavour. Frederic Leighton's *Elijah* could almost have been painted for a grand baroque seventeenth-century Roman church; Solomon J. Solomon's *Samson* would surely have won a major prize at a nineteenth-century Paris Salon; John Gibson's *Tinted Venus* can be compared with the work of many followers of Canova and Thorwaldsen; Stanhope Forbes's *Street in Brittany* reflects the enthusiasm all over Europe in the 1880s for the paintings of Bastien-Lepage.

Early Victorian art is less cosmopolitan but often more original. Millais's *Isabella*, with its intensity of symbolism and of expression, is his first Pre-Raphaelite painting - the subject is doomed young love from Keats's poem of the same name and the composition is deliberately archaic. Ford Madox Brown's *Waiting* has a simple, modern, domestic subject, like so many early nineteenth-century British paintings, but treated with the religious fervour of early Flemish art. John Brett's *Stonebreaker* has a much less obvious symbolism but is a supreme example in paint of Ruskin's belief in the accurate rendering of every detail of the natural world.

The Liverpool contribution to early Pre-Raphaelitism is well represented by D.A. Williamson's intense and brilliant north Lancashire landscapes of the early 1860s and by W.L. Windus's *Burd Helen* - his first Pre-Raphaelite painting with its moral subject rich in pathos, taken from a Scottish ballad. Later Pre-Raphaelitism was less sharply focused in technique and its emotional content was more sensual, more poetic, more dreamy - indeed there are clear links with the Aesthetic Movement. Burne-Jones's *Sponsa de Libano* and Albert Moore's *The Shulamite* both depict the passionate heroine of the Song of Solomon, while Moore's later *Summer Night* shows the artist moving away from pure form towards Pre-Raphaelite symbolism. The cult of Dante and of his love for Beatrice is well represented on a high poetic level by Rossetti's *Dante's Dream* and on a more prosaic and popular plane by Henry Holiday's *Dante and Beatrice*. Alone of the Pre-Raphaelites Holman Hunt remained faithful to early ideals and his *Triumph of the Innocents* - for all its supernatural imagery - still contains a realistically Palestinian peasant family on a journey with their ass.

Social realism was a very different movement but with its own ambiguity - Herkomer's *Eventide* is more than an indictment of Victorian workhouses and in Paris it was much admired by the Decadent critic J.K. Huysmans. Similarly in sculpture Thornycroft's *The Mower* is both an ideal figure and the first life size statue of an English farm labourer. Onslow Ford's *Peace* with its adolescent figure, naturalistic modelling and rich, detailed, symbolic accessories is a more typical example of the 'New Sculpture'.

The Walker Art Gallery was fortunate in its leaders. P.H. Rathbone, a younger son of one of Liverpool's leading merchant families, spent his early life in insurance but then became Chairman of the Gallery for most of its first twenty years; he combined a catholic

William Hamo Thornycroft (1850-1925)
British
The Mower, c. 1882-94
Bronze, height 190.5 cm
Purchased 1894; inv. no. 4136

This is probably the first important life size statue of a manual labourer in Britain and reflects the desire of the artists of the 'New Sculpture' to widen their repertory in the direction of naturalism and of every day life. Indeed the sculptor was inspired by seeing a mower at work on the river banks during a Thames boating trip. All the same, the figure is also a carefully arranged image of thought and reflection plainly inspired by Donatello and associated by the sculptor with a quotation from Matthew Arnold's poem *Thyrsis*.

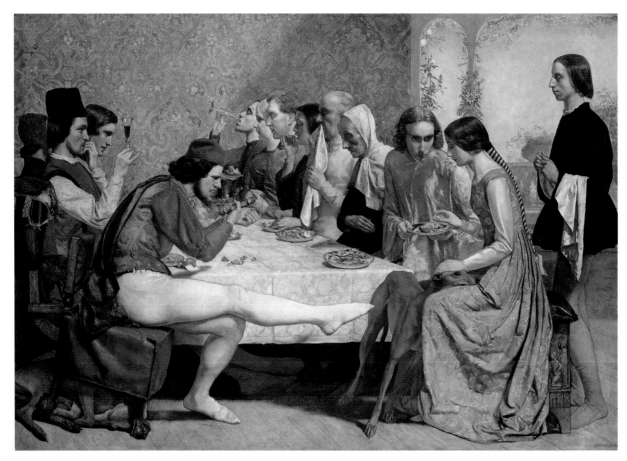

John Everett Millais
(1829-98)
British
Isabella, 1848-49
Canvas, 103 x 142.8 cm
Purchased 1884;
inv. no. 1637

One of the very first paintings in the new Pre-Raphaelite style, *Isabella* was begun shortly after the foundation of the Pre-Raphaelite Brotherhood in 1848, when Millais was only nineteen. The harshly brilliant colour combined with sharp detail, the deliberately unbalanced composition and the self-conscious angularity and flatness were all controversial features of Pre-Raphaelitism, loosely inspired by early Italian painting. The subject was taken from a poem by John Keats, itself derived from a story by the 14th century Italian writer Boccaccio about the love between Isabella, the sister of wealthy Florentine merchants, and their poor, low-born apprentice Lorenzo. The jealous brothers later murdered Lorenzo, but Isabella found his body, cut off the head and buried it in a pot of basil which she watered with her tears; the ending is foreshadowed by the pot of herbs in the background. The highly individualised faces include a portrait of Millais' friend and fellow Pre-Raphaelite Brother Rossetti (rear centre), drinking from a wineglass.

taste, embracing both Pre-Raphaelites and Naturalists, with a sharp eye for the young progressive artists of the Newlyn School and of the early years of the New English Art Club - although, always conscious of popular taste, he could also buy less demanding paintings like *And when did you last see your father?* by W.F. Yeames.

George Audley, who made his fortune from beer and whisky, was more active as a collector than as a member of the Walker Art Gallery's governing committee and around the early 1920s bought for the Gallery late Victorian masterpieces at auction just when they were cheap and unfashionable - Liverpool is indebted to him for nearly all its paintings by George Clausen and for Stanhope Forbes's *By order of the Court* as well as for about a further fifty notable mid- or late Victorian paintings. James Smith of Blundellsands (just north of Liverpool), a wine merchant, was one of the most important patrons of G.F. Watts during the artist's later years and Watts's *Four Horsemen of the Apocalypse* from Smith's collection are some of the grandest and most terrifying images of Victorian pessimism. In 1877, the year that the Gallery opened, Andrew Kurtz, a local industrialist, commissioned for it Frederic Leighton's great *Elijah* in order to establish proper standards for the future; in Victorian art at least he would not be disappointed.

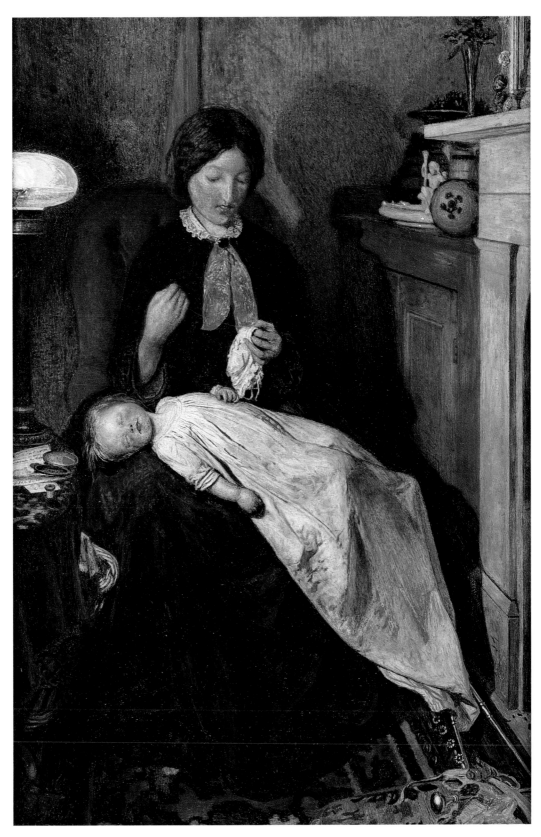

Ford Madox Brown (1821-93)
British
Waiting: an English fireside of 1854-55, 1851-55
Panel, 30.5 x 20 cm
Purchased 1985 with the aid of the National
Heritage Memorial Fund, the Pilgrim Trust and
the Friends of the National Museums &
Galleries on Merseyside; inv. no. 10533

The woman is waiting for her soldier husband to return
from the Crimea: his portrait miniature is on the table. The
artist's wife and daughter posed for the picture. This every-
day scene in an ordinary middle-class room lit by lamplight
and firelight has been painted with a quiet intensity, suggest-
ing a madonna and child in modern dress.

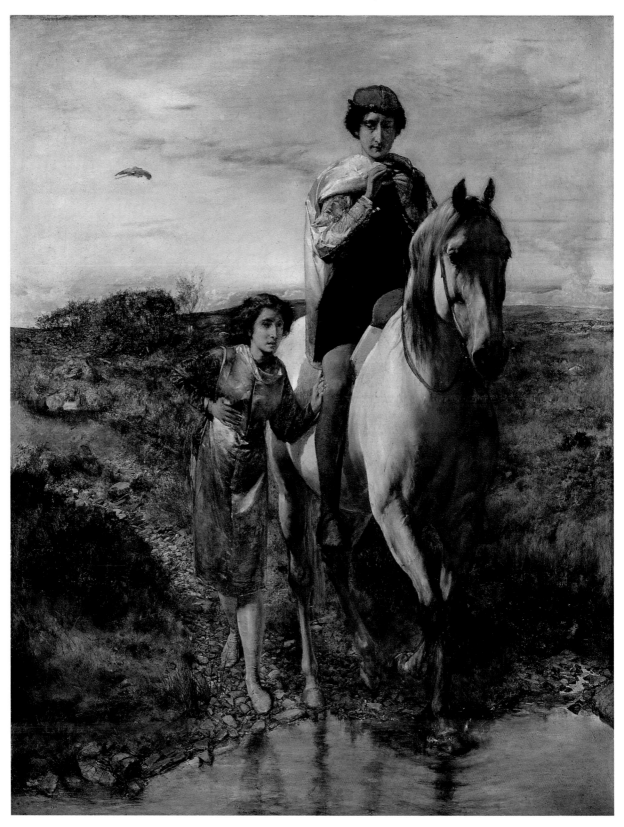

William Lindsay Windus (1822-1907)
British
Burd Helen, 1856
Canvas, 84.4 x 66.6 cm
Purchased 1956;
inv. no. 158

Windus, a Liverpool painter, was converted to Pre-Raphaelitism after a visit to the Royal Academy in 1850. This, his first picture in the new style, was based on the Scottish border ballad of *Burd Helen* who was made pregnant by her cruel lover. So infatuated was she, that she ran by the side of his horse as his foot page.

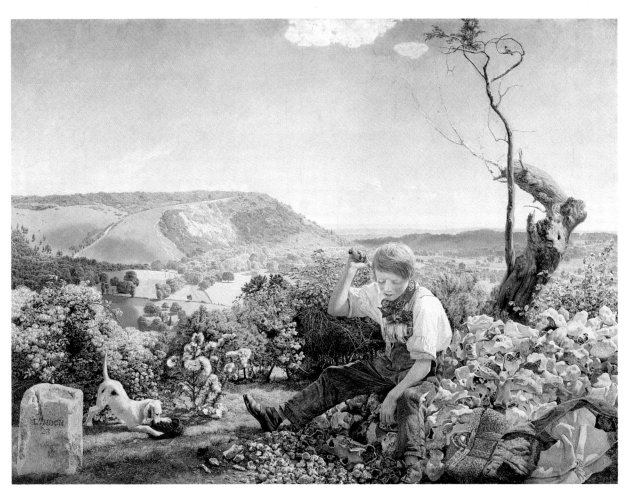

John Brett (1831-1902)
British
The Stonebreaker, 1857-58
Canvas, 51.3 x 68.5 cm
Bequeathed by Mrs Sarah Barrow 1918;
inv. no. 1632

A tour-de-force of Pre-Raphaelite truth to nature.
The boy is knapping flints for road-making, a task
often given to paupers. His figure and clothing,
the plants, the rocks, the sky, the shadows and
every detail of the distant Surrey landscape are
transcribed with scientific accuracy, reflecting
Brett's interest in the writings of John Ruskin.

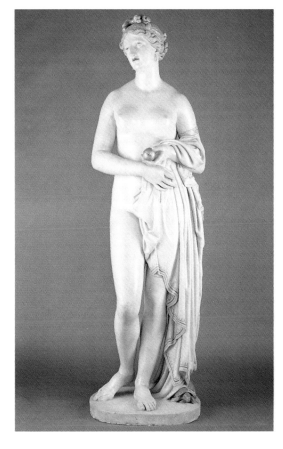

John Gibson (1790-1866)
British
The Tinted Venus, c. 1851-1856
Tinted marble, height 175 cm
Purchased 1971;
inv. no. 7808

Gibson was among the first neo-classical
sculptors to paint his sculptures - it became
generally known in the 19th century that
this had been the practice in ancient Greece.
His aim was not realism as there is no
attempt to simulate flesh colours, but his
Venus was still denounced as 'a naked
impudent English woman'. She carries the
apple presented to her by Paris as the sym-
bol of her beauty and power.

Daniel Alexander Williamson (1823-1903)
British
Spring, Arnside Knot and Coniston Range of
Hills from Warton Crag, 1863
Canvas, 27 x 40.6 cm
Bequeathed by James Smith 1923; inv. no. 784

The early work of this Liverpool-born painter showed little awareness of Pre-Raphaelitism. In 1861 he moved to Warton-in-Carnforth in North Lancashire, where he painted a series of small, vibrant Pre-Raphaelite landscapes, remarkable for their luminous colour.

James Lamb (1817-1902)
British
Cabinet, c. 1878
Ebony veneered, inlaid with silver, 150 x 230 x 50 cm
Purchased 1992; inv. no. 1992.61

Probably the cabinet exhibited by the Manchester firm at the Paris International Exhibition of 1878, where they won a gold medal.

Hubert von Herkomer (1849-1914)
British
Eventide: a scene in the Westminster Union, 1878
Canvas, 110.5 x 198.7 cm
Purchased 1878;
inv. no. 751

Originally drawn by Herkomer as a magazine
illustration, the subject is the bleak interior of the
St James Workhouse, Westminster, an institution
for female paupers. Paintings drawing attention
to social problems such as poverty, homelessness
and unemployment were unusual in Victorian art,
but a number of social realist pictures were exhib-
ited amidst some controversy in the 1870s.

Alfred Stevens (1817-75)
British
Buffet from the dining room at Dorchester House
c. 1860
Walnut and mahogany, height 480 cm
Purchased 1942;
inv. no. 3438

R.S. Holford commissioned Stevens to decorate
the dining room at Dorchester House in London
in about 1856. The work was unfinished at
Stevens's death. The house was demolished in
1929. The Walker also has richly carved mirrors
and doors from the room.

Dante Gabriel Rossetti (1828-82)
British
Dante's dream, 1871
Canvas, 216 x 312.4 cm
Purchased 1881;
inv no 3091

Rossetti had a life-long interest in the Italian poet Dante. This painting represents an episode from the *Vita Nuova* in which Dante dreams that he is lead by Love to the death-bed of Beatrice Portinari - the object of his unrequited passion. In this, his largest ever painting, Rossetti creates a visionary world using soft rich colours and complex symbols: the attendants wear green for hope, the spring blossoms signify purity, the red doves the presence of love, the poppies the sleep of dreams and death. The model for Beatrice was Jane Morris, with whom Rossetti had a long-term affair.

Frederic Leighton (1830-96)
British
Elijah in the Wilderness, 1877-78
Canvas, 234.3 x 210.4 cm
Presented by A.G. Kurtz 1879;
inv. no. 31

The prophet Elijah is fleeing from Jezebel who is determined on his death. In this painting he is asleep in the wilderness and an angel from God is bringing him bread and water. The angel seems to have just landed, his splendid wings still extended, but the prophet, his magnificently muscled nude body contrasting with the fluttering draperies of the rather effeminate angel, still lies asleep, as the angel looks tenderly down on him. This is one of the greatest academic paintings of the Victorian era.

Edward Poynter (1836-1919)
British
Faithful unto death, 1865
Canvas, 115 x 75.5 cm
Presented by Charles Langton, 1874;
inv. no. 2118

A Victorian moral exemplar of absolute devotion to duty: the sentry
stands at his post whilst Pompeii and its inhabitants are destroyed by the
eruption of Vesuvius. Poynter's source was the excavation at Pompeii of
the remains of a soldier in full armour, used as the basis for an imaginary
incident in Bulwer-Lytton's popular historical novel *The Last Days of
Pompeii* (1834).

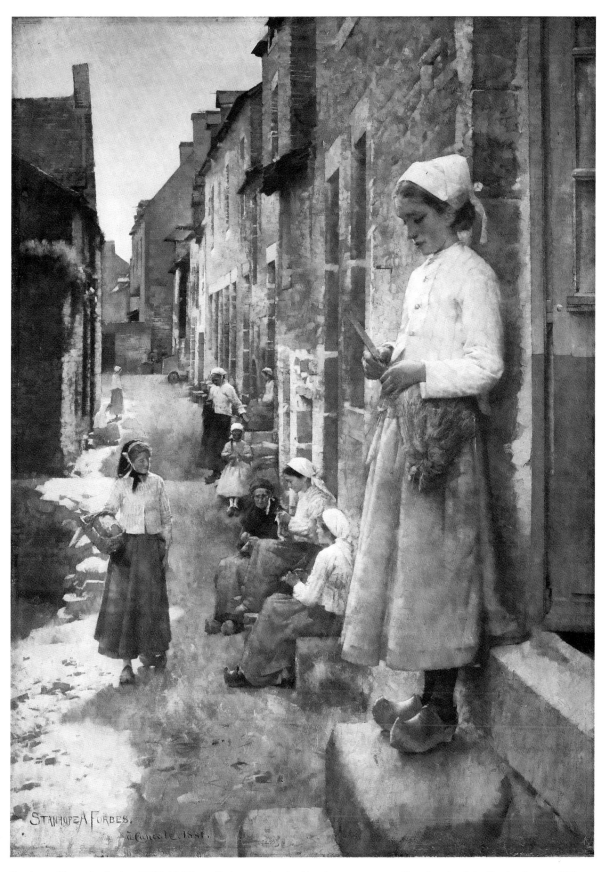

Stanhope Alexander Forbes (1857-1947)
British
A Street in Brittany, 1881
Canvas, 104.2 x 75.8 cm
Purchased 1882;
inv. no. 509

Forbes was inspired by the contemporary French artist, Jules Bastien-Lepage. This, his first out-of-doors painting (and arguably his masterpiece), shows Breton women knitting and net making in a Cancale street. The blue tonality, general absence of shadow and distinctive brushstroke are about as close as British avant-garde art at this time came to accommodating certain aspects of Impressionist practice. Forbes subsequently was the principal instigator of 'The Newlyn School' - a Cornish-based artist's colony.

William Holman Hunt (1827-1910)
British
The Triumph of the Innocents,
1876-87
Canvas, 157.5 x 247.7 cm
Purchased 1891;
inv. no. 2115

Joseph is shown leading Mary and the infant Christ on their nocturnal flight into Egypt. They are accompanied by the souls of the innocent children massacred by Herod. Garlanded in flowers, the children are borne along on a visionary stream of bubbles, symbolic of the promise of the Millenium following the coming of the Messiah. Hunt gives a typically unorthodox interpretation to a traditional story from the Bible, by using complex symbolism and authentic settings and costume, based on what he had seen on his several visits to the Holy Land. The *Triumph of the Innocents* was Hunt's last major Biblical subject.

Henry Holiday (1839-1927)
British
Dante and Beatrice, 1884
Canvas, 142.2 x 203.2 cm
Purchased 1884; inv. no. 3125

At his death Holiday was described as 'the last Pre-Raphaelite', and this picture was probably in part inspired by Rossetti's several Dante subjects. Dante is shown being ignored by Beatrice (but not by her companions) as they pass him near the Santa Trinità Bridge, Florence.

William Frederick Yeames (1835-1918)
British
And when did you last see your father?,
1878
Canvas, 131 x 251.5 cm
Purchased 1878;
inv. no. 2679

This is an imaginary scene which might
have occurred during the English Civil
Wars in a royalist house occupied by
the parliamentarians. The artist was
inspired to paint it by the innocent and
candid character of a young nephew
who lived with him. The suspense of
the subject and the simplicity of the
composition made it very popular, par-
ticularly in waxworks and in history
textbooks.

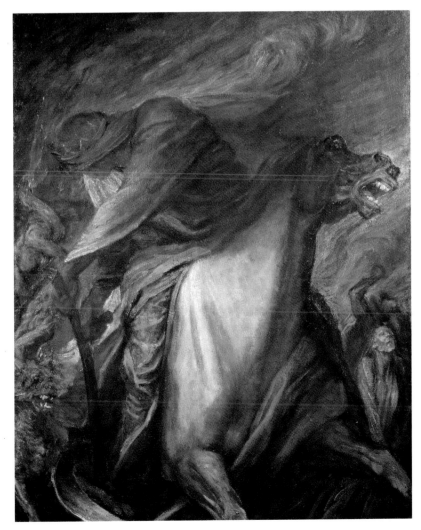

George Frederic Watts (1817-1904)
British
The Rider on the pale horse, about 1882
Canvas, 66.5 x 53.4 cm
Bequeathed by James Smith 1923;
inv. no. 1744

This is one of the four horsemen of the
Apocalypse described thus in the Book of
Revelation: 'And I looked, and behold a
pale horse: and his name that sat on him
was Death, and Hell followed with him'.
The other three horsemen painted by
Watts are also in the Gallery but, although
only a sketch, this is the most unforget-
table image. The rider, his face invisible,
scythes grimly through humanity while
against a fiery sky even the horse rears
upwards in terror, its mouth wide open,
seeming to emit a shriek of horror.

George Clausen (1852-1944)
British
The Shepherdess, 1885
Canvas, 64.7 x 46 cm
Presented by George Audley 1932;
inv. no. 434

Clausen's early paintings follow closely the principles of the French artist Jules Bastien-Lepage whose work was much admired in the early years of the New English Art Club. The girl's rather awkward pose - and her colossal boots - suggest an authentic peasant atmosphere enhanced by the way the landscape rises up sharply behind her seeming to enclose her within it. The grey light and carefully varied focus and brush stroke are further elements of this style. The painting was first owned by John Maddocks of Bradford, the most important patron of Clausen and of other progressive artists of the 1880s.

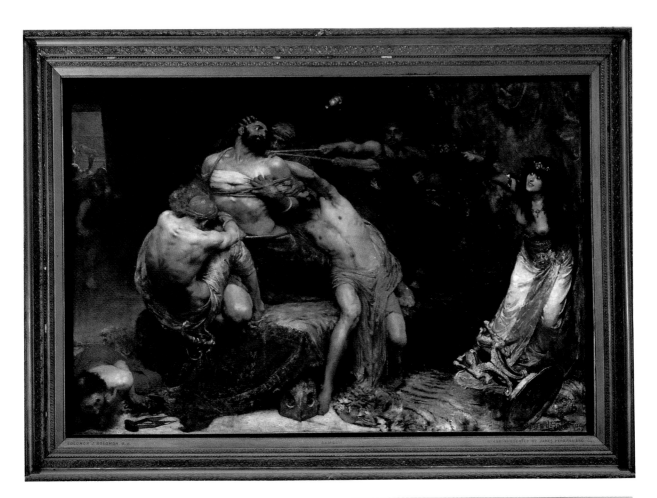

Solomon Joseph Solomon (1860-1927)
British
Samson, c. 1886-87
Canvas, 244 x 366 cm
Presented by James Harrison 1887;
inv. no. 3131

Samson, having lost his strength when
Delilah cut off his hair, is being bound by
the Philistines. Delilah on the right mocks
him. Here is a young artist trained in
Paris and anxious to demonstrate his
command of those academic skills highly
valued there - anatomy above all, but also
expression, grouping and pose.

Edward Onslow Ford (1852-1901)
British
Peace, 1887-89
Bronze, height 183 cm
Purchased 1891;
inv. no. 4213

Peace is represented by a young girl
with a dove and the palm branch
of victory standing on the armour
of war. Although all the symbols
are individually conventional
enough, giving them to a very natu-
ralistically modelled nude young
girl in an unusual and vivacious
pose is an example of that new
approach to allegory for which the
'New Sculpture' was famous.

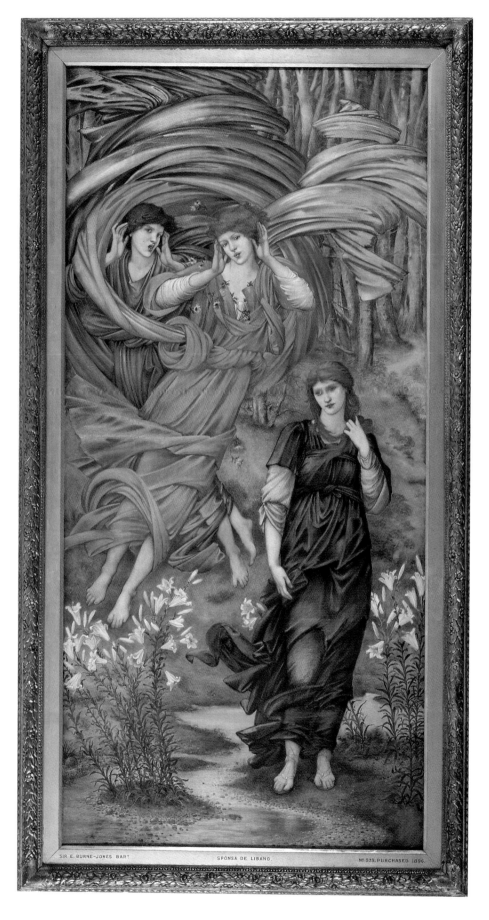

SIR E. BURNE-JONES BART. SPONSA DE LIBANO. Nº 539. PURCHASED 1896.

**Edward Burne-Jones
(1833-98)
British**
Sponsa de Libano, 1891
Gouache and tempera on
paper, 332.5 x 155.5 cm
Purchased 1896;
inv. no. 113

Based upon the biblical 'Song
of Solomon', this shows the
North and South winds blow-
ing, as requested by King
Solomon, upon his bride of
Lebanon. Despite this being
a rather voluptuous biblical
episode, Burne-Jones empha-
sises the languorous dream-
like and chaste nature of the
bride, surrounded by lilies
that are symbolic of virginity.
Burne-Jones's figure-style is
inspired by Botticelli and the
flat and decorative linear
treatment is like stained glass
or tapestry. An earlier tapes-
try design was the basis for
this picture.

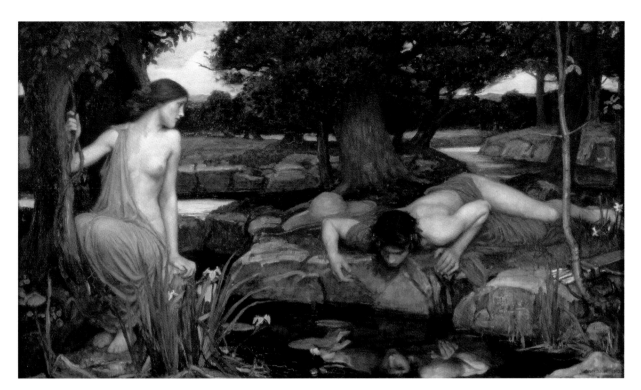

John William Waterhouse (1849-1917)
Echo and Narcissus, 1903
Canvas, 109.2 x 189.2 cm
Purchased 1903;
inv. no. 2967

The unhappy nymph Echo was condemned to repeat the last words spoken to her. She fell in love with the beautiful youth Narcissus, but he rejected her and was punished by falling in love with his own reflection. Waterhouse was of a younger generation than Rossetti and Burne-Jones, and his subjects of doomed and unhappy love were prettier, less disturbing and more widely popular than theirs.

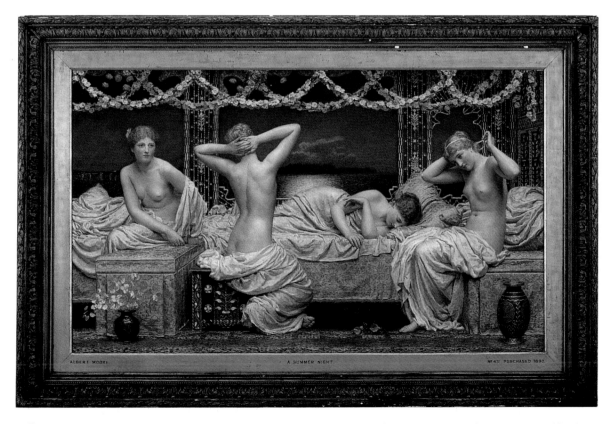

Albert Moore (1841-93)
British
A summer night, c. 1887-90
Canvas, 132 x 228.5 cm
Purchased 1890;
inv. no. 2125

Moore's paintings were informed by the study of Greek sculpture and Japanese art, and by the idea of 'art for art's sake'. His rhythmically posed female figures, combined with decorative accessories, were vehicles for the exploration of an abstract language of form, colour, line and pattern. *A summer night* shows four women preparing for sleep on a luxurious balcony overlooking a moonlit lagoon. Despite the deliberate lack of story or allegorical meaning, a note of eroticism, common in the artist's late work, is evident.

77

Impressionism, Post-Impressionism, Symbolism & Camden Town

Conservative taste rather than simply lack of money prevented the acquisition of Impressionist and Post-Impressionist pictures by the Walker until about 1935. The appointment of Frank Lambert to the directorship of the Gallery in 1931, and the £20,000 given in the Wavertree bequest marked the beginning of a less timid purchasing policy. Lambert admired the paintings of Sickert and British Post-Impressionist artists, particularly Gilman, Gore, Bevan and the so-called 'Camden Town' painters who specialised in depictions of everyday intimate interiors and metropolitan street views. Lambert bought Gilman's *Mrs Mounter* - usually considered his masterpiece - and acquired by purchase and gift four outstanding Sickerts. Although Lambert staged a large exhibition of modern prints and drawings at the Walker in March 1938, which included works by Picasso, Matisse, Dali and Klee, and added a major surrealist display as part of the 1938 Liverpool Autumn Exhibition it was not until well after the Second World War that the gallery gave any serious attentions to the purchase of more modern continental pictures. Virtually all purchases were of British art. However, even moderately 'modern' works by British artists caused difficulties. Both Lambert and the Arts & Libraries Committee Chairman, Vere Cotton, wanted to buy a Paul Nash painting for the collection in Summer 1938 but were outvoted by their fellow committee members. J. McIntosh Patrick's *Springtime in Eskdale*, was purchased, although costing five times as much.

Lambert's successor, Hugh Scrutton, concentrated upon buying representative late nineteenth-century French paintings: between 1959 and 1968 pictures by Vlaminck, Monet, Cézanne, Vuillard, Seurat, Sargent, Courbet and Degas were purchased - usually with the help of substantial grant-in-aid from various government agencies and also from local benefactors. Fortunately, Impressionist pictures were not then being sold for the high prices they now obtain.

A few avant-garde pictures had however made their way into the collection. For example Segantini's *Punishment of Lust*, 1891, a Symbolist work, was bought in 1893 largely at the prompting of P.H. Rathbone, the then Chairman of the Walker Art Gallery Committee. The most important piece of Symbolist sculpture, *Mors Janua Vitae* by Gilbert, was a gift to the gallery, as was Rodin's *Minerva*. The purchase of Tissot's *Catherine Smith Gill and two of her children* in 1981 brought back to Liverpool the only picture by one of the French Impressionist circle to have been painted in the city. Tissot was a political refugee in England for some years and in 1877 visited Liverpool to paint Mrs Gill at her home in Woolton - in the same year that the Walker Art Gallery opened.

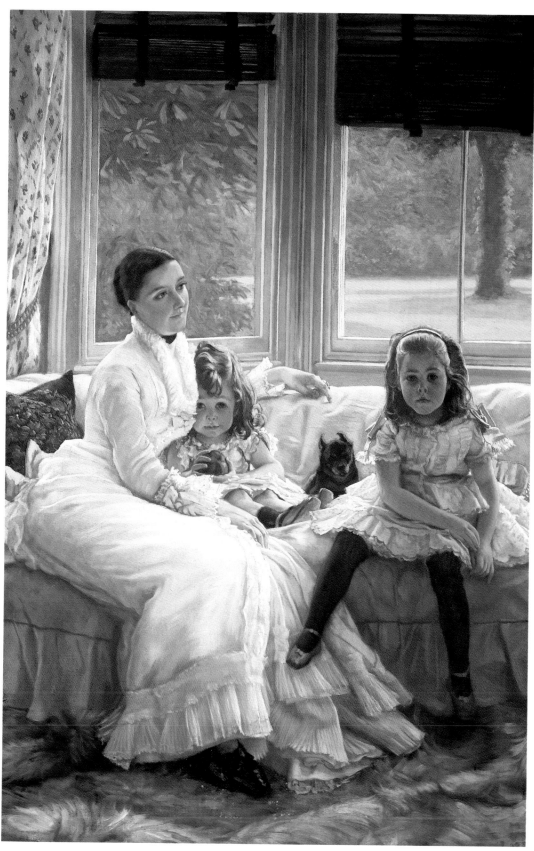

James Jacques Joseph Tissot (1836-1902)
French
Portrait of Mrs Catherine Smith Gill and two of her
children, 1877
Canvas, 152.5 x 101.5 cm
Purchased 1979 with the help of the National Art
Collections Fund; inv. no. 9523

Catherine Smith Gill, wife of a Liverpool cotton-broker, is
portrayed with two of her children, Robert and Helen, at
Lower Lee in Woolton, a Liverpool suburb. Tissot exhibited
with the Impressionists, settled in England after 1870, and
was a friend of the Gill family.

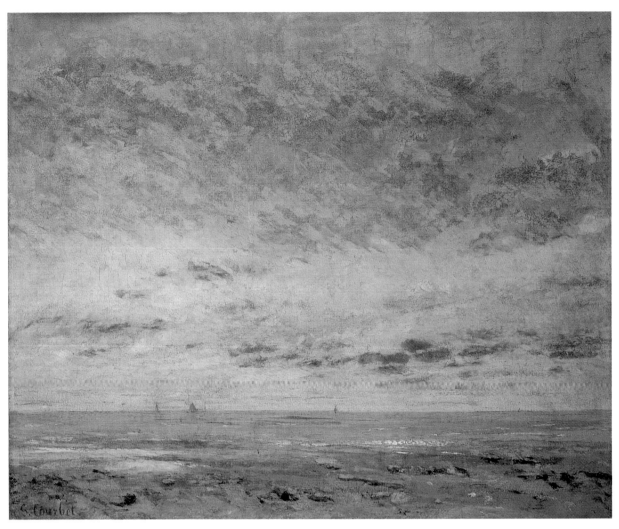

Gustave Courbet (1819-77)
French
Low tide at Trouville, 1865
Canvas, 59.5 x 72.5 cm
Purchased 1961 with the help of the National Art Collections Fund;
inv. no. 6115

The great French realist painter was profoundly moved by the sea and returned to it as a subject at regular intervals. He concentrated on immense expanses of sea and sky, reducing incident to a minimum and creating an essay in subtle tonal modulation. With this and similar paintings, Courbet and his friends Boudin and Whistler brought the seascape into the modern era, and provided a distant, but direct antecedent for colour-field abstract painting in the 20th century.

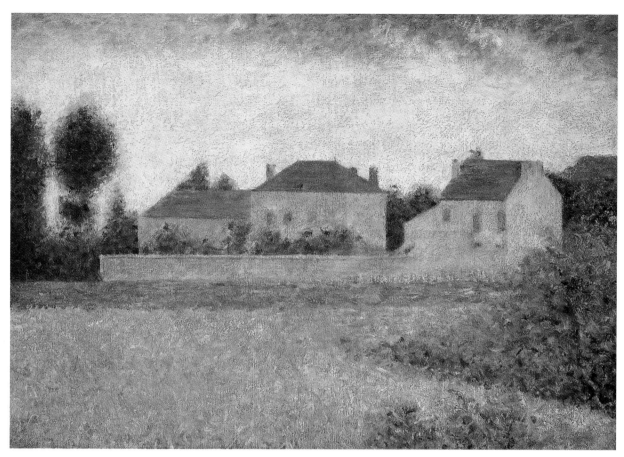

Georges Pierre Seurat (1859-1891)
French
Ville d'Avray, white houses, 1882
Canvas, 33 x 46 cm
Purchased 1961 with the help of the National Art
Collections Fund; inv. no. 6112

This oil sketch, depicting the countryside outside Paris, dates from early in
Seurat's career. It shows the artist's growing interest in the Divisionist technique
and scientific colour theory.

Paul Cézanne (1839-1906)
French
The Murder, c. 1867
Canvas, 65.4 x 81.2 cm
Purchased 1963 with the
help of the National Art
Collections Fund;
inv. no. 6242

Early in his career Cézanne
painted a group of works
depicting violent themes.
This image may have been
derived from a popular
broadsheet. The dark tone
and vigorous handling of
the paint, along with the
contorted bodies and faces
of the figures, reinforce the
desperate and menacing
nature of the subject.

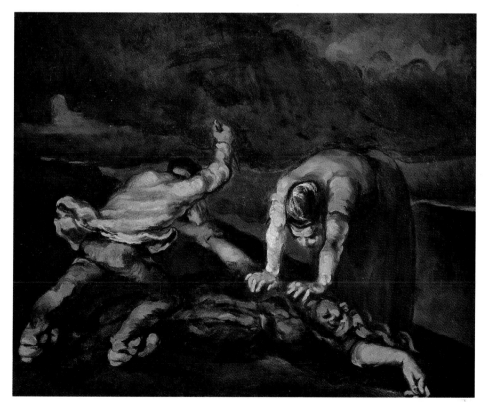

81

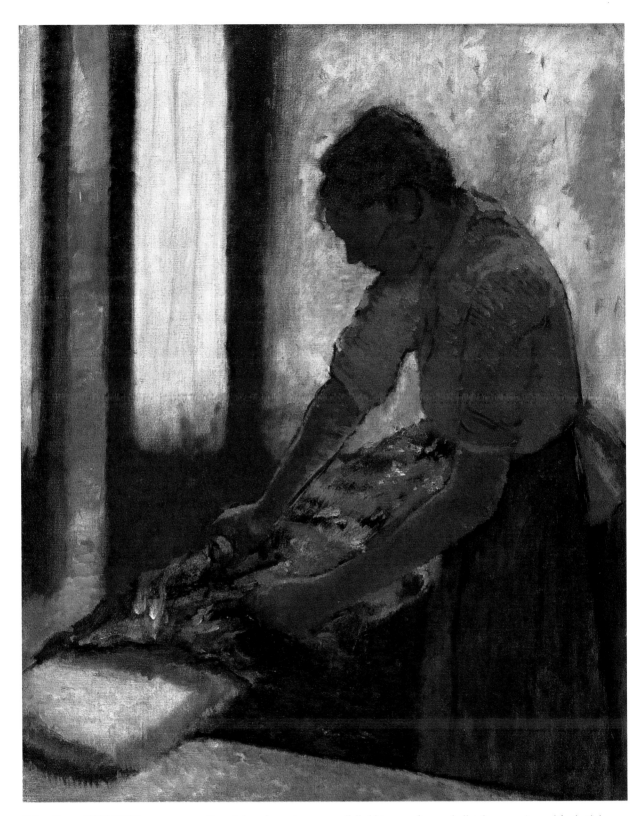

Edgar Degas (1832-1917)
French
Woman ironing, c. 1890
Canvas 80 x 63.5 cm
Purchased 1968 with the help of the
National Art Collections Fund;
inv. no. 6645

Degas's laundress pictures parallelled his more famous ballet dancer series and for both he studied the precise movements of women at work. The art of Degas was that of a 'Naturalist', depicting what was considered vulgar - laundresses were commonly perceived as borderline prostitutes - in a way that was almost scientific. A double viewpoint is used - looking straight at the woman's face, and down at her board. Her outlined and cropped figure also indicate Degas's debts to both Japanese art and snapshot photography.

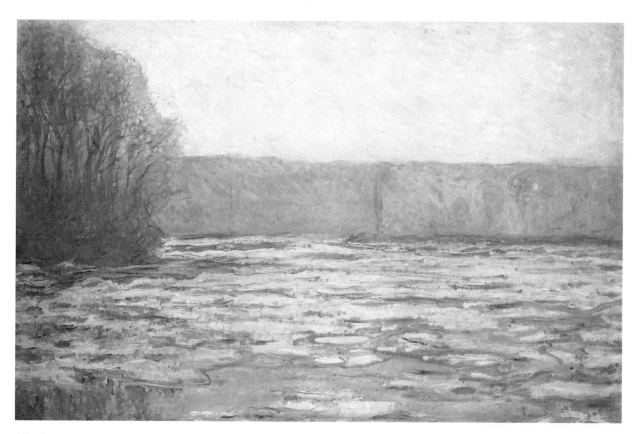

Claude Monet (1840-1926)
French
Break-up of the ice on the Seine, c. 1890
Canvas 65 x 100 cm
Purchased 1962; inv. no. 6133

A wintry early morning view towards two of the narrow islands of trees at Bennecourt near Giverny on the River Seine. By 1890 Monet complemented his on-the-spot Impressionist practice with extensive studio re-working. This resulted in many pictures with close-toned atmospheric harmonies - most famously in his Rouen cathedral and haystack series but nonetheless still evident in this painting.

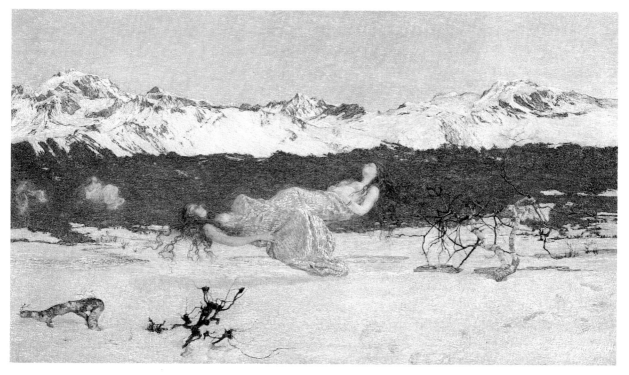

Giovanni Segantini (1858-99)
Italian
Punishment of lust, 1891
Canvas, 99 x 172.8 cm
Purchased 1893; inv. no. 2127

As Segantini moved towards Symbolism around the end of his life he became attracted by a Buddhist poem, *Nirvana,* written by Luigi Illica. The poem describes the gradual redemption of mothers guilty of abortion or child neglect achieved by their painful passage through a dismal icy valley. Nirvana (or final expiation) is presumably represented by the distant splendid mountain range painted from the Swiss Alps near St Moritz. The artist was protesting at the emancipation of women from their traditional role as mothers.

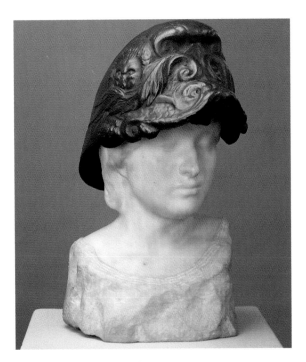

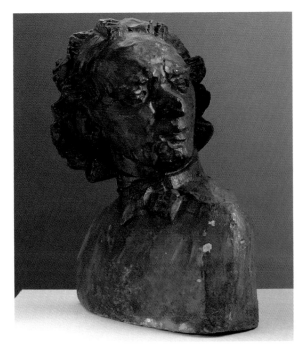

Auguste Rodin (1840-1917)
French
Minerva, c. 1896
Marble and bronze, heigh 48 cms
Bequeathed by James Smith 1923; inv. no. 4181

A whole series of busts of Minerva were inspired by Rodin's friendship with Mrs Mariana Russell, wife of the Australian painter John P. Russell. The use of different materials within the same sculpture to achieve textural variety became very popular in the late 19th century.

Henri Gaudier Brzeska (1891-1915)
French
Bust of Alfred Wolmark, c. 1913
Plaster, height 67.3 cm
Purchased 1954; inv. no. 4112

Showing the painter Alfred Wolmark and made at the time that Gaudier was connected with Wyndham Lewis's 'Vorticist' movement, this bust with its exaggerated facets of face and hair, is redolent of machinery surfaces and cog-wheels.

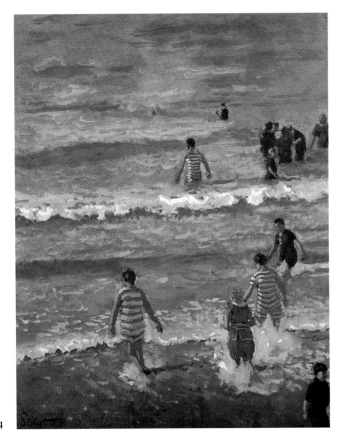

Walter Richard Sickert (1860-1942)
British
Bathers, Dieppe, 1902
Canvas, 131.4 x 104.5 cm
Purchased 1935;
inv. no. 2262

Sickert's viewpoint without a horizon and daring off-centre positioning of figures is intended as an immediate, almost snapshot, capturing of a glimpse of reality. Strongly influenced by his friend Degas, Sickert was the most powerful of British artists working in the Post-Impressionist idiom. This and several other pictures were made as interior decor for a Dieppe café but the patron disliked them and sold them off. Sickert's triangular grouping of the figures in striped costumes gives compositional tautness, and yet once recognised as such it seems almost whimsical.

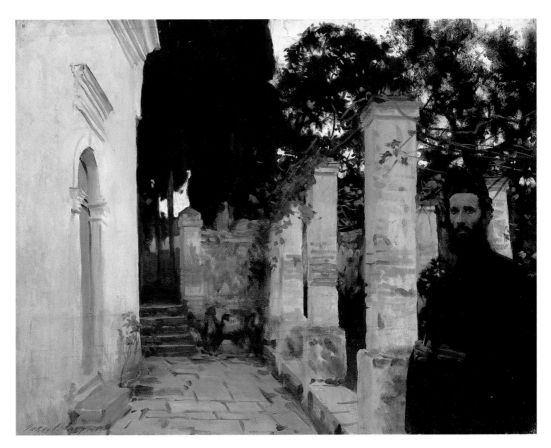

John Singer Sargent (1856-1925)
American
Vespers, 1909
Canvas, 71 x 91.5 cm
Presented by George Audley, 1928; inv. no. 2634

Rapid, dazzling brushwork made Sargent the outstanding portrait painter of his day. His virtuoso technique is here applied to a landscape, painted during a visit to Corfu in 1909, which in its spontaneity and its rendering of sunlight is akin to the work of the French Impressionists.

Edouard Vuillard (1868-1940)
French
Madame Hessel on the sofa, 1900
Canvas 54.6 x 54.6
Purchased 1966;
inv. no. 6217

Lucie Hessel and her picture-dealing husband were close friends of Vuillard. Madame Hessel is shown relaxing in her rue de Rivoli apartment surrounded by pictures that are by Cézanne, Renoir, Lautrec and Vuillard himself. Vuillard used a distinctive dry brushstroke and the cardboard itself under the paint contributes to line, modelling and shadow.

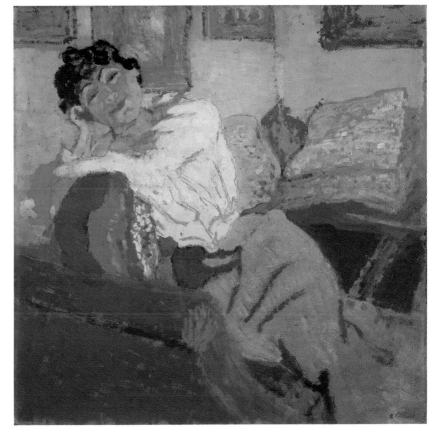

85

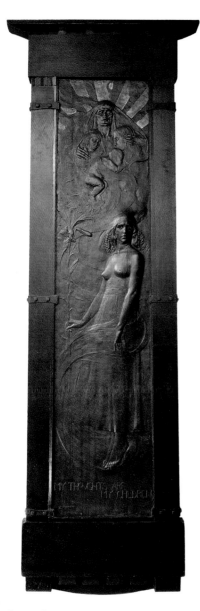

George Frampton (1860-1928)
British
My thoughts are my children, 1894
Bronze, framed in wood, overall size 333 x 116 cm
Presented by Meredith Frampton, 1984;
inv. no. 10461

George Frampton was an exponent of the 'New Sculpture', a movement in late 19th-century British sculpture whose followers favoured naturalistic modelling but often chose symbolic or mysterious subject matter. In this work a mother and her children are shown among swirling clouds or draperies above the hovering figure of a young woman. The meaning is unclear, and the whole composition has the look of a dream or an apparition. Frampton derived his technique of modelling in low relief from Italian Renaissance sculptors like Donatello whose work he greatly admired.

Alfred Gilbert (1854-1934)
British
Mors Janua Vitae, c. 1905-07
Painted plaster and wood, height 208.5 cms
Presented by E. Percy Macloghlin 1909;
inv. no. 4230

The title means : 'Death, the door to life', and this is a model for a tomb commissioned by Eliza Macloghlin for her husband Percy, a provincial doctor, and for herself - their ashes were to be placed in the casket clasped by husband and wife. They were both atheists and so the symbolism is pagan not Christian, with Anteros (selfless love) on the left lower panel and Eros (sexual love) on the right - this must refer to their mutual love. The monument itself (in bronze) is in the Royal College of Surgeons in London but it was on this model that the sculptor himself worked with its brilliant, ghostly colour and its rich, fantastic detail.

Harold Gilman (1876-1919)
British
Mrs Mounter, 1916/17
Canvas 91.8 x 61.5 cm
Purchased 1943;
inv. no. 3135

Mrs Mounter, the artist's landlady at 147 Maple Street, London, was the subject of several of Gilman's drawings and paintings. This sympathetic portrait brightens the colours of a rather ordinary interior creating a striking, patterned effect. Mrs Mounter's face becomes a patchwork of colours which reflect surrounding surfaces. Gilman was a close friend of Sickert and was strongly influenced by French Post-Impressionist painters, particularly the works of Van Gogh and Gauguin.

Later 20th-Century Art

The Walker Art Gallery served as the local food office between 1939 and 1950 - although even in those dark days it bought Lowry's *Fever van* in 1943 - and it re-opened to the public with no regular exhibition of contemporary art on a national basis. The Liverpool Academy exhibitions were held in the Gallery but these were strictly local - although a considerable number of paintings by significant Merseyside artists were acquired from them. In 1957 however thanks to the enlightened sponsorship of Sir John Moores the first John Moores Liverpool Exhibition was held with two not entirely compatible objectives as recorded in the first catalogue: 'to give Merseyside the chance to see an exhibition of painting and sculpture embracing the best and most vital work being done today throughout the country' and 'to encourage contemporary artists, particularly the young and progressive'.

Sir John Moores was himself an amateur artist and he was particularly keen on this second aim; in the 1950s neither the London dealers nor the Royal Academy gave a warm welcome to progressive art however defined and the John Moores Exhibitions rapidly attained pre-eminence among advanced artists and art critics. The jury was changed each year and included such distinguished figures in the early years as Sir John Rothenstein (1957), Sir Alan Bowness (1959), André Chastel (1959), Sir William Coldstream (1963) and Clement Greenberg (1965). Stylistic uniformity was thus avoided and each exhibition presented a new challenge to artists, to critics and to the public.

Prizes were awarded and some of these were purchase prizes enabling the Walker Art Gallery to build up its collection of contemporary art with an assurance and an authority which had not been possible since the early years of the Autumn Exhibitions. Jack Smith's *Creation and Crucifixion* won the major purchase prize at the 1957 exhibition; Kitaj's *Red Banquet* was acquired from the 1961 show; Hockney's *Peter getting out of Nick's pool* received the first purchase prize in 1967; Hoyland's *Broken bride* came from the 1982 exhibition and the tradition still carries on today. Like the exhibitions the acquisitions covered a wide stylistic range reflecting the taste of very different juries - from Kitaj's historical reconstruction through Allen Jones's erotic imagery to Hoyland's abstraction.

The Gallery has not confined its purchases of contemporary art to the John Moores Exhibitions nor were these exhibitions the only major temporary displays of contemporary art in the Gallery over the last forty years. The Peter Moores Liverpool Projects of 1971 to 1986 were selected exhibitions concentrating on particular aspects of modern painting and sculpture and were not so rigorously confined to painted surfaces as the John Moores Exhibitions. There have also been a series of one man shows which still continue and at present concentrate on artists with strong Merseyside connections. These also have often related to major acquisitions: for example the purchase of Caulfield's *Still life: Autumn fashion* was followed a few years later by a major retrospective exhibition of his work at the Gallery.

Ben Nicholson (1894-1982)
British
Prince and Princess, 1932
Board, 29.5 x 46.7 cm
Purchased 1993 with the help of the National Art
Collections Fund and of the Friends of the
National Museums and Galleries on Merseyside;
inv. no. 1993.78

Inspired by the table-top still lifes of the Cubists, this picture has an autobio-
graphical significance, for the profiles on the playing cards are those of the artist
and the sculptor Barbara Hepworth, with whom he was sharing a studio at this
date. The emphasis on surface texture, the playful use of line and the flattening
of realistic space show the artist moving from representation towards the lyrical
semi-abstract compositions for which he is best known.

Lawrence Stephen Lowry
(1887-1976)
British
The Fever van, 1935
Canvas, 43.1 x 53.5 cm
Purchased 1943;
inv. no. 363

An ambulance in a narrow
street collects a diphtheria
or scarlet fever sufferer.
Lowry's views of working-
class Salford where he col-
lected rents have become
nostalgic icons of a now
defunct northern industrial
city life.

Jack Smith (born 1928)
British
Creation and Crucifixion, 1955-56
Hardboard, 243.8 x 304.3 cm
Presented by Sir John Moores 1957;
inv. no. 1236

The deliberately mundane interior suggests a link with 'kitchen sink' realism.
This was denied by the artist who wrote 'my concern at that time was to
make the ordinary seem miraculous'. The painting won first prize at the first
of the biennial series of John Moores Liverpool exhibitions held in 1957.

Paul Nash (1889-1946)
British
*Landscape of the moon's
last phase*, 1943/44
Canvas, 63.5 x 75.8 cm
Presented by the
Contemporary Art Society
1947; inv. no. 3143

This view of Wittenham
Clumps, Berkshire, features
regularly in Nash's late mys-
tical landscapes which fol-
low in the English Romantic
tradition of Palmer and
Blake. The sun, moon and
the changing seasons
became personal symbols of
life and death, while the
place itself, the site of an
ancient earthworks, evokes
man's primitive past.

Lucian Freud (born 1922)
British
Interior at Paddington, 1951
Canvas, 152.4 x 114.3 cm
Presented by the Arts Council 1951; inv. no. 3134

The model, Harry Diamond, was a friend of the artist. He spent six months posing for the picture. Freud creates a mood of depression and neglect, while his unrelenting scrutiny of every detail and the figure loitering outside add to the sense of unease. Freud said 'the task of the artist is to make the human being uncomfortable'.

Allen Jones (born 1937)
British
Hermaphrodite, 1963
Canvas, 213.5 x 122 cm
Purchased 1963; inv. no. 6190

Several of Allen Jones's prints, sculptures and paintings explore the tension between male and female. These two fused figures express the Jungian notion that truly creative art requires both feminine and masculine characteristics. It is thus a metaphorical self-portrait of Jones's own artistic quest. The overtly erotic female imagery is characteristic of much of Jones's subsequent art.

R.B. Kitaj (born 1932)
American
The Red Banquet, 1960
Collage on canvas, 152.5 x 152.5 cm
Presented by Sir John Moores 1961; inv. no. 6115

The subject of this picture is a celebrated dinner given by the American Consul in London in 1854 for some of Europe's most notable political refugees. Kitaj's treatment focuses on the modern and emblematic aspects of the event. The painting is one of a group of works which established him as a central figure in British Pop Art; for although his preference for literary and historical themes now seems to distance him from the movement, many of the formal mannerisms here, such as the liking for collage and bare canvas and the intrusiveness of pictorial device, are hallmarks of early Pop style.

Henry Moore (1898-1986)
British
Falling warrior, 1956-57
Bronze, 63.5 x 147.5 x 78.5 cm
Purchased 1961; inv. no. 5598

Moore wrote 'I wanted a figure that was still alive... a figure in the act of falling and the shield became a support... emphasising the dramatic moment that precedes death.' His figure, one of eleven cast, fuses landscape rock and natural forms with naked body; as though the earth absorbs death prior to future regeneration.

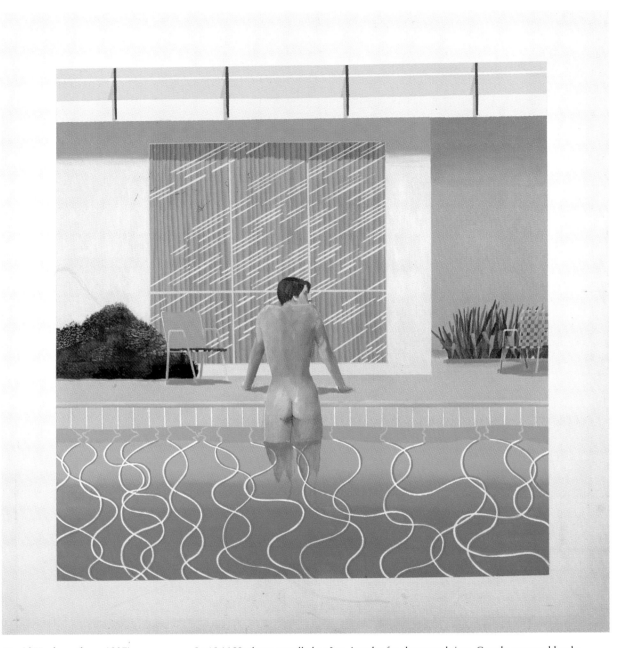

David Hockney (born 1937)
British
Peter getting out of Nick's pool, 1966
Canvas, 213.4 x 213.4 cm
Presented by Sir John Moores, 1968;
inv. no. 6605

In 1966 Hockney travelled to Los Angeles for the second time. Greatly attracted by the sunny climate and relaxed atmosphere of West Coast America, he began to record in his work characteristics of the lifestyle there. A series of paintings based on the theme of the swimming pool were produced. Here, Hockney's friend Peter Schlesinger is depicted climbing out of the swimming pool of Nick Wilder, a Los Angeles gallery owner. The painting is a composite view. Schlesinger did not actually model in the pool; the pose derives from a snapshot of him leaning against his MG sports car. The white border and square format of the work are reminiscent of the Polaroid prints Hockney used as studies for the composition.

Patrick Caulfield (born 1936)
British
Still life: Autumn fashion,
1978
Canvas 61 x 76.2 cm
Purchased 1981;
inv. no. 9590

Caulfield's eclectic pictorial
vocabulary borrows from
Cubism, comic book outlines
and highly detailed magazine
photography. Although he
often parodies kitsch or
clichéd images, his pictures
invariably retain a quiet
authority that is principally
the result of highly schematic
and almost traditional com-
position. Caulfield does not
consider himself to be a
'Pop' artist, although he is
often categorised as such.

Stephen Farthing (born 1950)
British
Louis XV Rigaud, 1976
Canvas, 183 x 137.5 cm
Presented by the Friends of Merseyside
County Museums and Art Galleries 1977;
inv. no. 9137

In this pithy critique of Hyacinthe Rigaud's
portrait of Louis XV Farthing combines a
Pop artist's sensitivity to packaging with a
postmodern taste for reference and quota-
tion. A cocktail of 20th-century painting
styles, with elements of collage, caricature
and graffiti, it flirts exuberantly with artifice
and youthful self-display.

Adrian Wiszniewski (born 1958)
British
Landscape, 1987
Canvas, 263 x 310 cm
Purchased 1987;
inv. no. 10614

This allegorical double portrait of
the artist and his wife, painted in
Liverpool at the time they were
expecting their first child, reflects
upon man's relationship with
nature. The strongly mannered
draughtsmanship - a high point of
80s neo-expressionism - and the
light, thin colour give the work a
lyrical atmosphere of primitiveness
and fecundity.

John Hoyland (born 1934)
British
Broken Bride 13.6.82, 1982
Canvas, 254 x 228 cm
Presented by Sir John Moores 1982;
inv. no. 10365

Hoyland's principle in this work,
which won the John Moores first
prize in 1982, has been to build up
the structure through formal con-
trast. Individual colours, shapes
and textures achieve force and lumi-
nosity when seen against adjoining
areas. The painting is both cerebral
and sensual, underpinned by an
instinctive search for radiance and
harmony.

Index

THE BLACKPOOL SIXTH FORM
COLLEGE LIBRARY